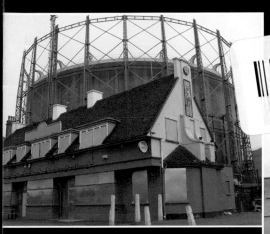

Derelict London

Paul Talling

BOOKS

Published by Random House Books 2008

10 9

First published in Great Britain in 2008 by Random House Books

Random House Books
Random House, 20 Vauxhall Bridge Road,
London SW1V 2SA

www.randomhouse.co.uk

Addresses for companies within The Random House Group Limited
can be found at: www.randomhouse.co.uk/offices.htm

The Random House Group Limited Reg. No. 954009

A CIP catalogue record for this book is available from the British Library

ISBN 9781905211432

Printed and bound in China by C&C Offset Printing Co. Ltd

Designed by Richard Marston

Contents

Introduction 6

Living: Houses and Flats 8

Working: From Docks to Factories and Shops 26

Eating and Drinking: Pubs and Cafés 60

Relaxing: From Public Baths to Cinemas 92

Serving: From Schools and Hospitals to Fire Stations 124

Travelling: From Boats to Trains 160

Fighting: Pill Boxes and Shelters 186

Resting: Cemeteries and Chapels of Rest 196

Regenerating: Buildings Back from the Brink 208

Introduction

My fascination with derelict London buildings dates back to an early spring morning in 2003 when I noticed that an abandoned candle factory in Wandsworth was finally succumbing to the wrecker's ball. There was something rather poignant about seeing this once vibrant building finally biting the dust, and it prompted me to keep a casual eye out for other buildings tottering on the edge of extinction. Soon, I realised to my slight horror, I had become obsessed. I took to wandering the streets at weekends, camera in hand, and eventually even went so far as to set up a website – *derelictlondon.com*. Any fears I may have had that I was the only person who found these places even remotely interesting were soon dispelled when I realised what a flood of visitors the website was receiving – nearly 700,000 in all so far. Many have posted comments with their stories about the buildings, or emailed me new ideas for places to snap.

For this book, I have selected just a few of the many hundreds of buildings I have visited over the years. Some have been included because their neglect seems scandalous to me. No one could walk past the beautiful Concrete House in East Dulwich or the Lighthouse Building in King's Cross, for example, without wishing that someone would take them in hand and restore them to their original

glory. In some cases, though, I have to confess that dereliction seems to be something of a blessing: it's hard to imagine that anyone ever very much liked the Island Block on Westminster Bridge roundabout or that people will miss the bleak Ferrier Estate when it finally disappears.

But for the most part I think the buildings recorded here simply show how London is – and always has been – an endlessly changing and evolving city. We see phone boxes and public toilets disappearing, but we also see regeneration in areas like King's Cross and the 2012 Olympics site. Old factories and wharves such as Millennium Mills lie abandoned, but others come back to life as shopping centres and homes. Even in the short time this book has been in preparation, some of the buildings shown will inevitably have been wiped off the face of the earth, while others may well have been put on the road to recovery.

All the buildings in this book are reminders of London's bygone days. Each one is full of stories that shed old, forgotten light on the city – from the brawls in Soho's rock 'n' roll pubs, to James I's banquets in Winchester Palace, Southwark. I hope this book demonstrates that London's derelict buildings deserve to be celebrated just as much as its new developments.

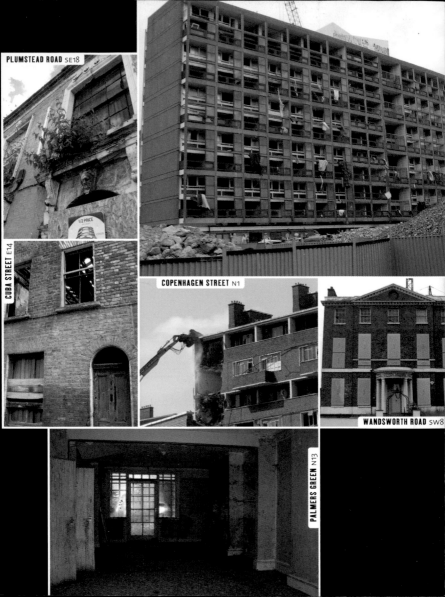

PLUMSTEAD ROAD SE18

CUBA STREET E14

COPENHAGEN STREET N1

WANDSWORTH ROAD SW8

PALMERS GREEN N13

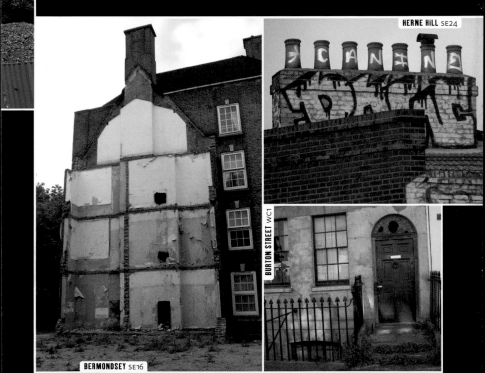

ALPINE ROAD, BERMONDSEY SE16

Living

Houses and Flats

HERNE HILL SE24

BURTON STREET WC1

BERMONDSEY SE16

The Concrete House

This house represents a curious mixture of the old and the new in that while it is very firmly Victorian in date and style, it is actually built from (rendered) concrete with artificial stone dressing. Constructed in 1873 by Charles Drake of the Patent Concrete Building Company, it is one of the very few surviving examples of a nineteenth-century concrete house in England. Drake was an innovative builder – a few years before he built the house he patented the use of iron panels for shuttering in the place of timber.

By the 1970s the house had become a children's home, run by a woman known as 'Auntie Lena', but since the 1980s it has been unoccupied, and the whereabouts of its owner are unknown. As it is a grade II-listed building it cannot be pulled down, but if the owner cannot be found it cannot be restored. Time is running out for the Concrete House.

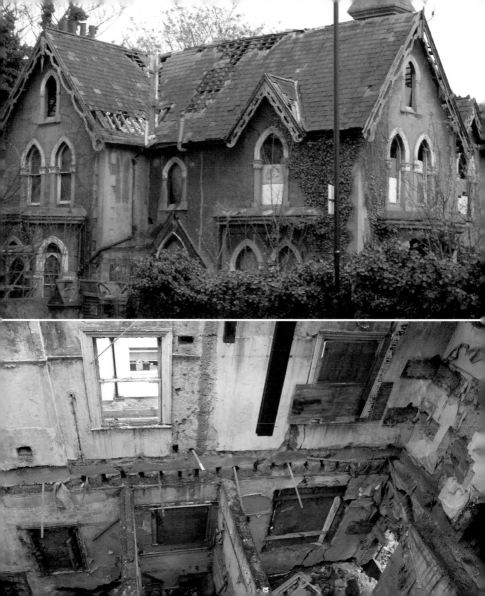

Wood Dene Estate

Peckham SE15

Many of the more brutal concrete monstrosities
constructed throughout London since the Second
World War are now disappearing before the bulldozer.
The 1960s Wood Dene Estate, which was designed in
large, concrete, six-storey blocks with long walkways,
is just one of those scheduled for destruction. Once
demolition had been decided upon, whole floors of
the flats were covered with metal shutters and tenants
gradually moved elsewhere – a process that took
five years.

As people left, Wood Dene became a magnet for
drug dealing, vandalism and shootings. It acquired
national notoriety in 2005 when Zainab Kalokoh was
shot in the head at her niece's christening party in the
community centre on the estate.

The council says it has plans
to build more than 300 homes for sale and rent on the
cleared site.

Northumberland Terrace

Many of London's more gracious homes are, or have been, in danger of being lost at some point in the past few decades. Northumberland Terrace, built in 1752 by Robert Plimpton for the Duke of Northumberland, is a depressing contemporary example. It was constructed on land previously occupied by medieval mansions, and the gate piers may have been part of the original Black House in which Henry VIII is said to have stayed from time to time.

One of the fourteenth-century Earls of Northumberland was known as Hotspur, a name made famous by Shakespeare in his play *Henry IV, Part 1*. The nearby Tottenham Hotspur Football Club was named after him. The crest of the club originally featured two lions, representing the crest of the Northumberland family, and a cockerel and ball; the badge has since been 'modernised' and the two lions removed.

The terrace as a whole has suffered from serious dilapidation. Some parts of the interior, however, have been restored in recent years – not always sympathetically.

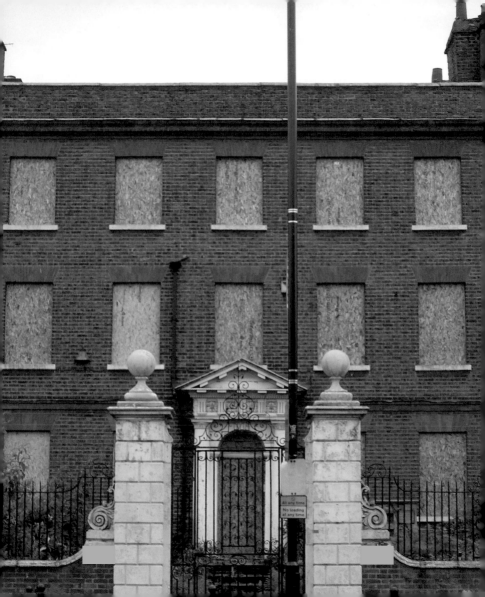

Culross Buildings

Time is very definitely running out for the Culross Buildings and Culross Hall in King's Cross – a black-smith's forge, which previously abutted the end of the Culross Buildings, has already been demolished and is now a car park.

Developed in 1891, the buildings were erected by the Great Northern Railway for its workers and for people made homeless by the demolition of houses for railway expansion. There is a flat roof, with railings round the edges, providing amenity areas for the residents and areas for drying washing. In more recent times, Culross Hall served as a base for socialist/political activists in London; this was one of their exhibition venues and meeting-houses.

Despite much opposition by campaigners, the buildings are earmarked for demolition as part of the multi-billion pound King's Cross redevelopment.

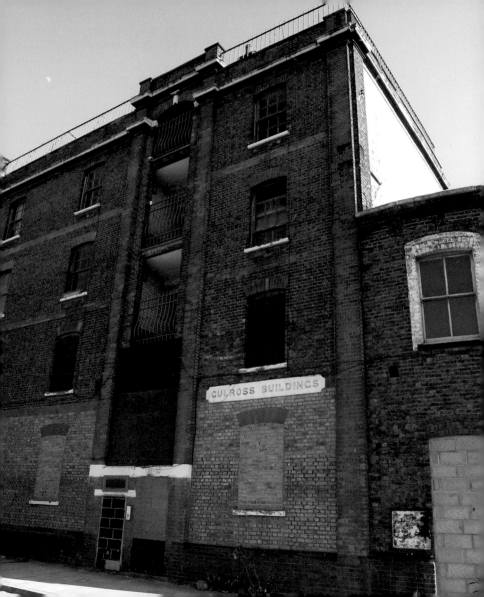

North Circular Road

Over the years there have been various proposed schemes to widen the North Circular, which links west and east London via the northern suburbs. Three hundred properties have at some time or other been scheduled for demolition. There is no doubt that there are serious bottlenecks on the North Circular, but many local people argue that widening the road would only attract more traffic, making one of Britain's most polluted roads even more hazardous to health.

The decades of uncertainty hovering over this stretch of road have given the homes and businesses on either side of it a forlorn air. Transport for London owns these buildings and is buying up more houses as residents move out. Many have been left to vandals, others boarded up to escape the attentions of arsonists and squatters.

Ferrier Estate

The huge Ferrier Estate in Kidbrooke has had a fairly unsavoury reputation ever since its construction on a disused military site by the Greater London Council in 1972. Built out of forbidding pre-fabricated blocks, it became notorious for crime, neglect and vandalism.

Over the last few years households have been moved out as the council prepares to demolish the estate to make way for a new housing development planned for 2018. Some homeowners, however, have refused to leave, as they feel the money that they are being offered to move is insufficient to buy a property on the open market.

Blocks have become derelict, with dark metal steel sheets covering landing windows and stairwells. Outward-facing windows have been ripped out to make them uninhabitable. While I was there, one remaining resident told me that the estate is infested with ants and rats.

St Mary's Lodge

Poor old St Mary's Lodge. Designed and constructed in 1843 by one of the leading architects of the day, John Young (who also designed the Royal Marsden Hospital), it was built for himself, his wife, their nine children and two servants and incorporates some wonderful architectural flourishes, such as arched windows and terracotta brickwork details. Young enlarged the house in the 1860s and also added an elegant garden at the rear. The Youngs remained at St Mary's Lodge until John Young's death in 1877, after which it remained a family home until 1959.

From the early 1960s, the local authority used St Mary's Lodge as a women's hostel, offering refuge to up to nine women at a time. The hostel was closed in the mid-1990s and the building and grounds were left unmaintained and unsecured. Vandals, squatters and the elements have left the house and grounds in a poor state, particularly following a major fire in 2005, and St Mary's Lodge's future is uncertain.

Coopers Road Estate

When the residents of the Coopers Road Estate off the Old Kent Road moved out four or so years ago, around 400 squatters moved in. They were well-organised and for a while were able to resist attempts by Southwark Council to evict them and to turn off the water supply to the two blocks. Now the outer wall has been removed to render the flats uninhabitable, exposing the multi-coloured interiors of people's old homes to passers-by.

Quite a few tower blocks in this area have been demolished, to be replaced by new low-rise homes.

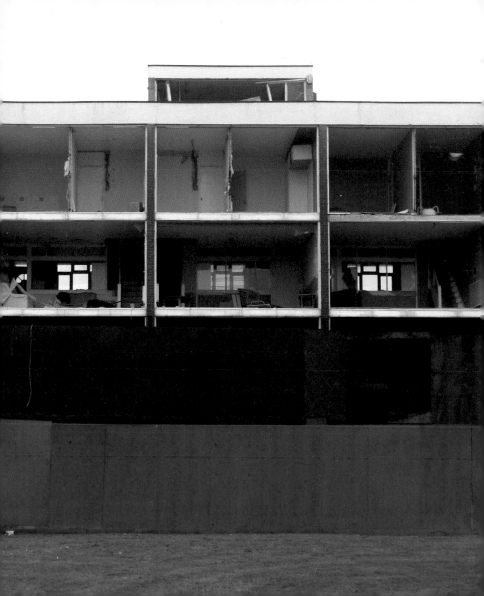

Working

From Docks to Factories and Shops

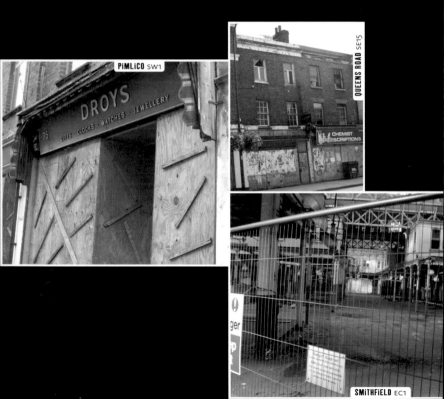

PIMLICO SW1

DROYS

76 GIFTS · CLOCKS · WATCHES · JEWELLERY

QUEENS ROAD SE15

CHEMIST
PRESCRIPTIONS

ger

p

SMITHFIELD EC1

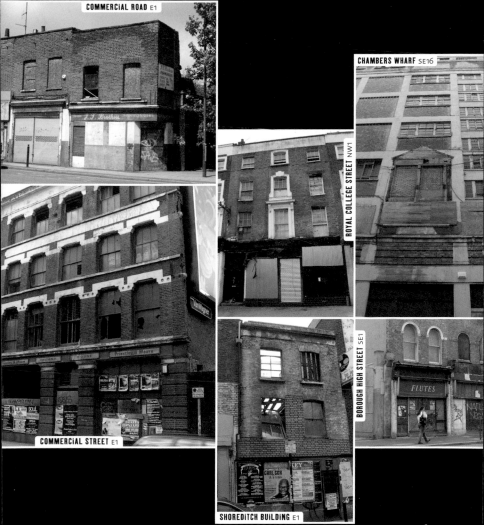

COMMERCIAL ROAD E1

CHAMBERS WHARF SE16

ROYAL COLLEGE STREET NW1

COMMERCIAL STREET E1

BOROUGH HIGH STREET SE1

SHOREDITCH BUILDING E1

Bow Creek

This is where the River Lee (or Lea) reaches its tidal estuary. It may not look much here, but it has played an important part in English history – in 896 King Alfred the Great is believed to have pursued an invading Danish fleet up the river, and because it lies outside the City of London and so was free from its regulations, the area around it was a centre of mills and of industrial activity throughout the Middle Ages.

During the 1800s the Thames Ironworks and Shipbuilding Company built around 900 vessels at its Bow Creek shipyard. Its memory is preserved in the badge and nickname of its works football team, West Ham United FC, known as the 'Hammers' not in reference to West Ham but to the crossed tools that appear on the club badge.

The creek has been used as a dumping ground for years and looks pretty bleak now, but is earmarked for redevelopment as part of the regeneration scheme that has come with the 2012 Olympics project. The Pura vegetable oil factory was demolished shortly after this photograph was taken in March 2007 to make way for the construction of 2500 homes.

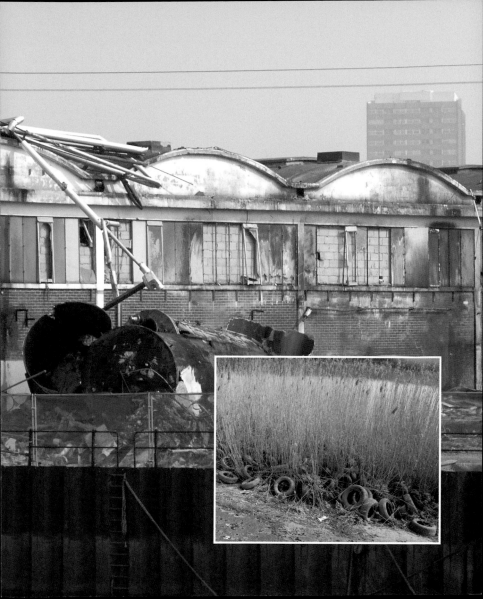

Youngs Ram Brewery

Wandsworth SW18

The earliest records of brewing on this site date
back to at least the early seventeenth century,
but in recent times its cramped location, and the
fact that the local authority expressed an interest
in acquiring and developing the land it stood on,
prompted the brewery to consider its options, and in
2006 the decision was made to sell up and move to
Bedfordshire. Chairman John Young died just days
before the brewery closed, and its final brew was
served at his funeral.

Now that the Ram Brewery has gone,
Fullers in Chiswick (where brewing has been going on
since Elizabethan times) remains the only significant
brewery still operating in London.

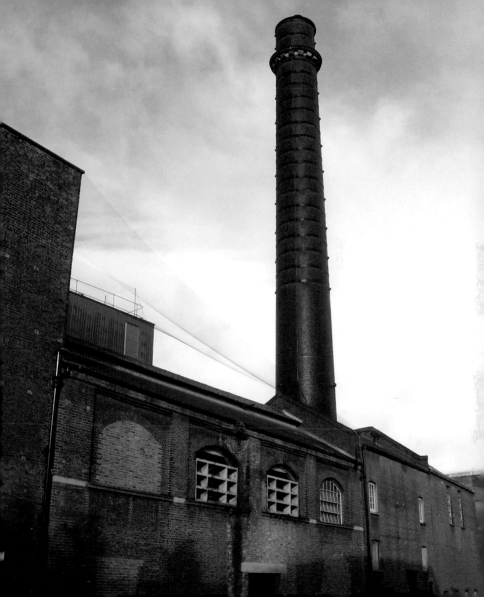

Royal Arsenal, Royal Laboratory and Dial Square

Woolwich SE18

The Royal Arsenal in Woolwich was formerly used for armaments manufacture and explosives research. The oldest surviving buildings on the Arsenal are those of the Royal Laboratory, which was completed in 1696 and which focussed its attention on the manufacture of ammunition for small arms and artillery.

The workers of Dial Square (the name of the workshops at the heart of the complex) formed Dial Square FC – later Woolwich Arsenal FC – in 1886, which played on nearby marshes. Included in the founding group were two former Nottingham Forest players, who wrote to their old club to ask if it would be prepared to let them have some kit. Forest responded with a full set of red jerseys and a ball. In 1915 a move was made north of the river to Highbury and the club dropped the Woolwich from its name to become Arsenal.

The Royal Arsenal ceased to be a military establishment in 1994. Much of the site is currently being redeveloped for luxury apartments and houses.

VIP Garage

This workshop was built in 1869 as a sail-makers'
and ship-chandlers' warehouse. It was occupied by
Caird & Rayner from 1889 to 1972 and was never
substantially altered, so the building retains its original
cast-iron window frames and two double loading
doors that open on to the Limehouse Cut. Caird
& Rayner were engineers and coppersmiths who
specialised in the design and manufacture of seawater
distilling plant for supplying boilers and drinking water
on Royal Navy vessels and Cunard liners.

The building is
the only one of its kind surviving in Tower Hamlets.
A housing trust owns the property and plans to
demolish the existing buildings to make way for a
block of flats.

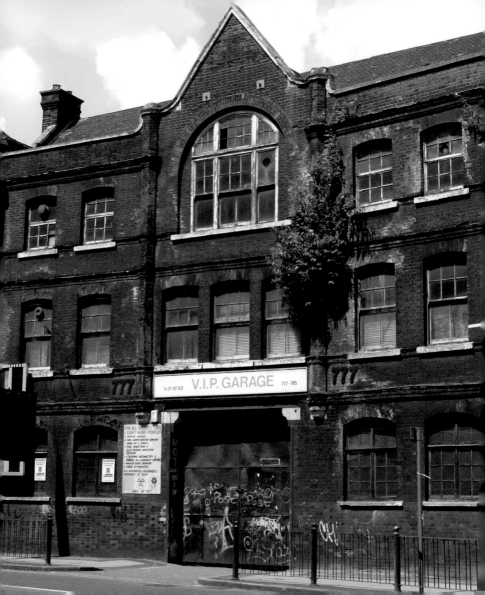

Tobacco Dock

Tobacco Dock is a grade I-listed warehouse constructed in around 1812 and formerly used as a store for imported tobacco. It is a brick building with beautiful vaults and some fine ironwork.

In 1990 the building was converted into a shopping centre, but the scheme was unsuccessful and the enterprise went into administration. Since the late 1990s the structure has been almost entirely unoccupied, although it is occasionally used for large-scale corporate events and part of the building recently accommodated the studios of the Channel 4 reality television show *Shattered*.

Only one outlet, the Frank & Stein sandwich shop, is currently in operation, but the site is nevertheless expensively maintained, with cleaners, full-time security staff and even a kestrel (to chase away pigeons). Walking around this desolate arcade is an eerie experience. In one shop there is even a pile of discarded pirate dummies.

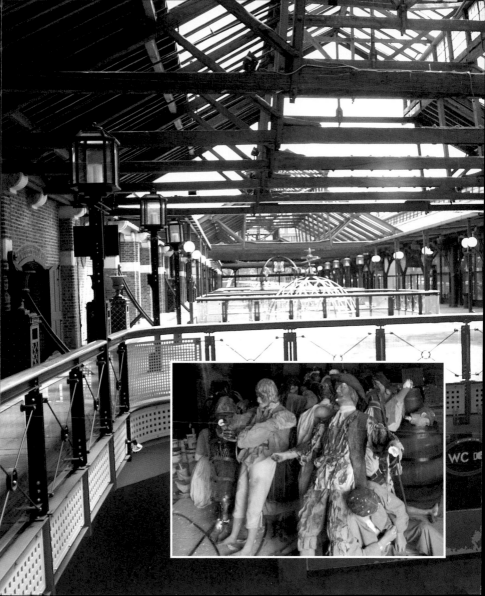

Lighthouse Building

This building was constructed in 1875 and the 'lighthouse' on the top is something of an enigma. Some claim that it dates back to the time when oysters were popular and cheap fast food and the 'oyster houses' that sold them were marked with a lighthouse. Some claim that the 'lighthouse' is really an old helter-skelter ride from a fairground. No one, though, seems sure.

Vacant for a number of years, the building formerly housed a group of squatters. One of them told me that when they were exploring one day they managed to lower themselves into an underground room from which a set of stairs led further down. They followed these for a while and eventually emerged on to an old tube platform.

This whole area is getting a facelift now that the Channel Tunnel international railway station has opened over the road at St Pancras station, and the plan is to redevelop the Lighthouse Building as office, retail and food and drink outlets.

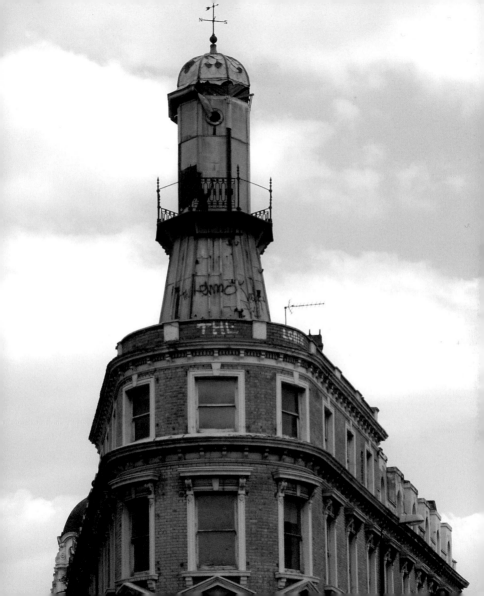

Lovell's Wharf

Greenwich SE10

Over the past 150 years this wharf by the River Thames has dealt with coal, lime, metal and gravel, and was used until the 1980s by Shaw Lovell as part of their metal transhipment operation. There is also believed to be an ice house on the site, built for a commercial ice company at the turn of the last century. On the side of the main wharf building there is a hole in the wall mysteriously marked 'HM Customs', with a bell still attached.

The site is now completely derelict. Two large cranes, known as 'Scotch derricks' and thought to be the last of their kind on the river, were removed in 2001, much to local dismay. The rest of the wharf is under threat of demolition to make way for new housing, which may include some tall tower blocks.

Parts of the 2000 film *Gabriel & Me*, starring Billy Connolly, were filmed at Lovell's Wharf.

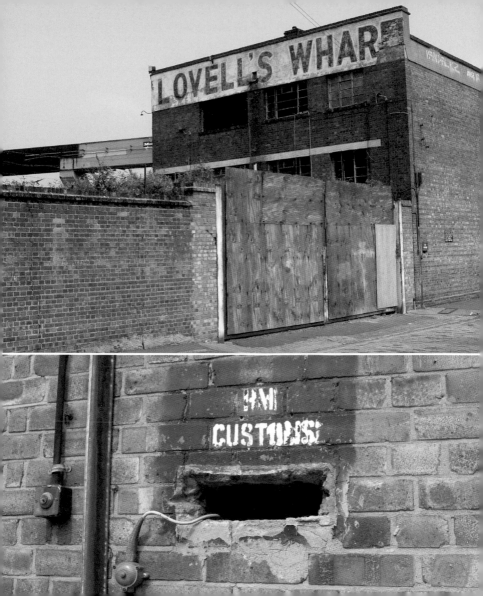

Chambers Wharf

Bermondsey SE16

London's river trade declined rapidly after the Second World War, and after standing derelict for some years, many wharves were redeveloped during the 1980s: they were converted into a mixture of residential and commercial real estate and became in the process some of the most upmarket and expensive properties in London. Chambers Wharf, though, is an exception. It has fallen into serious disrepair and is now threatened with demolition.

Despite its decaying appearance, part of the building is still used as a storage facility – to house gold bullion, locals have told me. Also lurking in the depths is a large Second World War air raid shelter which projects out from beneath Chambers Wharf and under the River Thames. Some episodes of the 1970s television drama *The Professionals* were filmed here, and Bodie and Doyle are to be seen running across the roof in one episode.

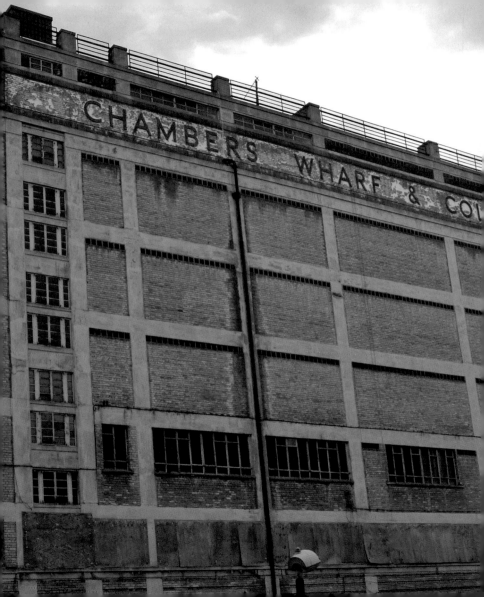

Smithfield Market

Smithfield, originally known as Smoothfield, was, as its
name suggests, once a large open space, famous for
its horse market, and for jousting and sporting events
– as well as public executions. It was also the site
where one of the leaders of the Peasants' Revolt, Wat
Tyler, was killed in 1381. And since the early Middle
Ages it has housed a livestock market.

Shown here is the General
Market, built in 1883 to the designs of Sir Horace Jones.
Bombed during the Blitz, it was repaired in the 1950s,
but now faces demolition at the hands of developers
who want to put office blocks here. The adjacent Meat
Market is still trading, but its lease expires in a few years'
time.

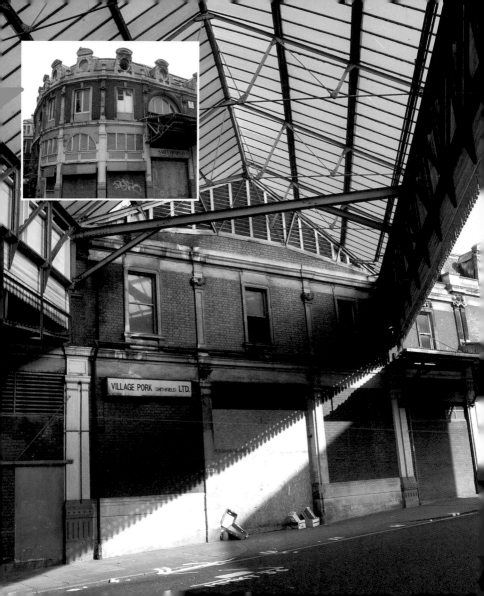

Fulham Power Station

Built in 1897, this power station was the largest such municipal facility in the country. Coal was supplied by boat up the River Thames, through Chelsea Creek.

Part of the building was demolished in the 1980s to make room for the Chelsea Harbour Club; part was kept as an energy substation. It has lain abandoned for several years, but is now being converted into a 'flagship' self-storage facility owned by the Big Yellow Self-Storage Company.

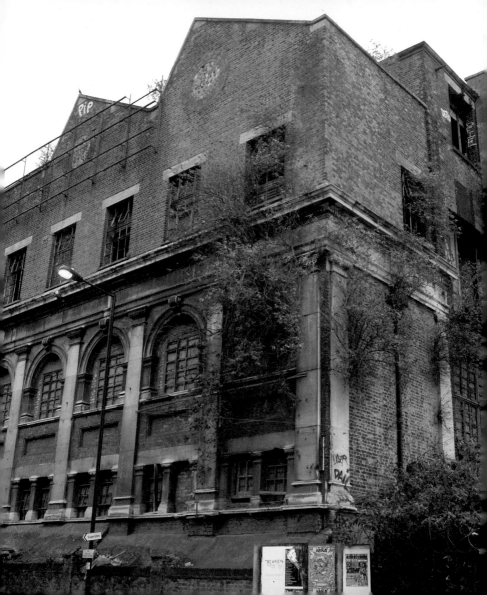

Tay Wharf

The Keiller & Sons jam factory occupied Tay Wharf
from 1880 until 1997. Fruit arrived at the factory by
ship, while sugar was supplied by the Tate & Lyle
refinery almost next door. The firm was taken over in
1920 by Crosse and Blackwell and is now a subsidiary
of Nestlé.

The entrance, which dates from 1900, is a rather
strange, tunnel-like affair. It may be that it was
designed in this way so that dockers could be
inspected as they left – just in case they were carrying
something that did not belong to them.

Tay Wharf is now
used by scrap iron and steel exporters.

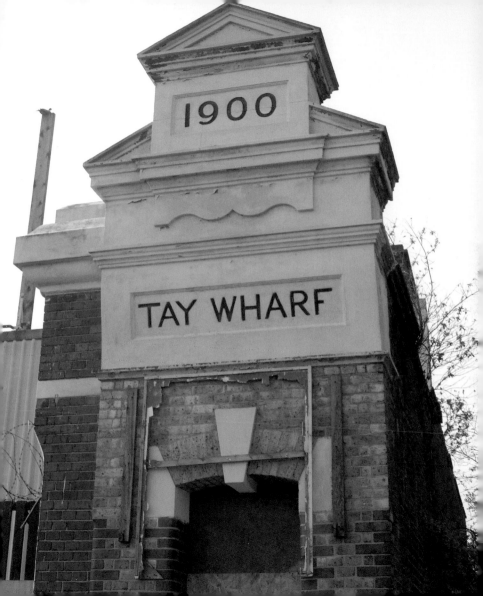

Palmers Pet Shop

Camden Town NW1

Founded in 1918, this was once the most famous pet shop in London – the ideal place to buy everything from chimpanzees to talking parrots. It attracted a starry clientele. Winston Churchill bought a kitten named Orlando here in the 1950s, the shop's owner receiving a cigar and a signed copy of Churchill's *My Early Life* in return. Other cat-fanciers, such as Charlie Chaplin, Dudley Moore and Peter Cooke, also visited, while Ken Livingstone came here to purchase pet newts.

Increasing rent, rates and insurance costs, combined with a general decline in pet sales, led to the shop's closure in the summer of 2005. The business relocated to smaller premises over the road, and now just sells pet foods and accessories.

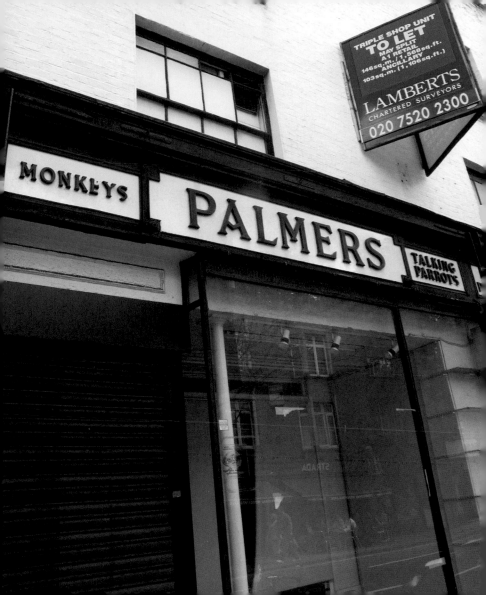

Millennium Mills

Built in the 1930s to replace earlier granaries and mills, the Millennium Mills were one of the largest (flour) mill complexes ever to be built in London. Industry in the docklands area of London began to decline in the 1980s, however, and this complex of reinforced concrete granaries finally succumbed in 1992 when Spillers Milling Limited moved out, transferring staff and production to their mill at Tilbury Docks. Since then the building has made frequent appearances on television, recent examples being in a trailer for the drama series *Life on Mars*, and as a backdrop for a Derren Brown programme featuring Robbie Williams.

Developers plan to build 5,000 new homes on this site and to convert the Millennium Mills into loft-style apartments. Many of these homes will have views over the Royal Docks and the River Thames. They may also enjoy the more dubious benefit of aircraft noise from the adjacent London City Airport.

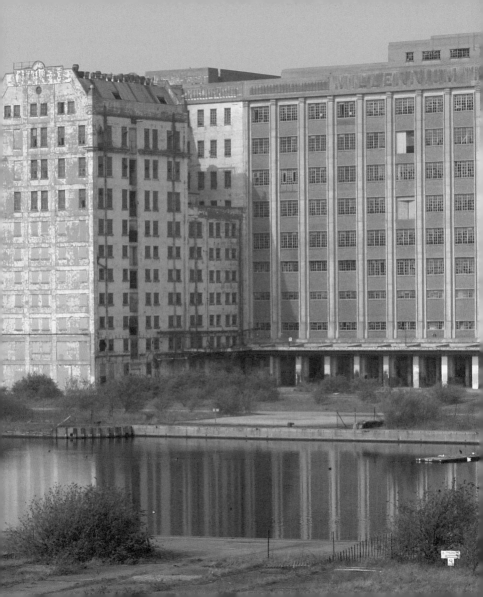

Battersea Power Station

Battersea Power Station is without doubt the most famous derelict building in London. Opened in 1937 it was designed by Sir Giles Gilbert Scott, the architect also responsible for Bankside Power Station and Liverpool Anglican Cathedral, and it originally had a chimney at either end. After the Second World War another, externally identical station was built alongside, giving the building its now familiar four chimneys.

The building is an unmissable landmark for the many people who commute from suburbia to Waterloo, and it has made numerous film and television appearances. It was, for instance, a setting in Alfred Hitchcock's 1936 film *Sabotage*, the Beatles film *Help!* and Monty Python's *The Meaning of Life*.

The power station closed in 1983 and plans were made to convert it into a theme park, but costs escalated and work stopped in 1989, leaving the building in its present semi-derelict state – without a roof, steelwork exposed to the elements and foundations prone to flooding. Currently there are proposals to have the new Energy Technologies Institute located here.

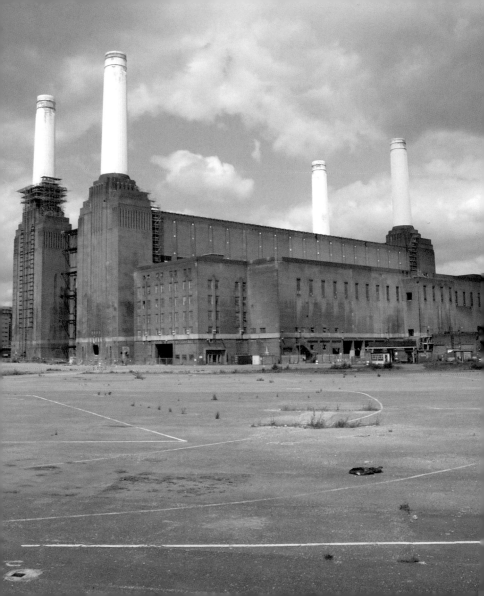

Chisenhale Works

Morris Cohen built the Chisenhale Works building
(called CHN Veneers) at the height of the Second
World War in 1943 to produce veneer for the
construction of Spitfire cockpits, as well as propellers
and plywood for Mosquito aircraft. The works closed
in 1972 and the building was then bought by the
London borough of Tower Hamlets.

In 1980 a group of artists
and a dance collective took over the lease at Chisenhale
Works as the Arts Place Trust after being forced to
relocate from their studio building in Butler's Wharf
in Docklands. During the winter of 1980–1, the artists
renovated part of the derelict building and created 40
studios. X6 Dance, meanwhile, established Chisenhale
Dance Space in the derelict Black Horse Brewery
building adjacent to Chisenhale Works.

Although many parts
of the old works pictured here still remain derelict,
there appear to be no plans to redevelop them.

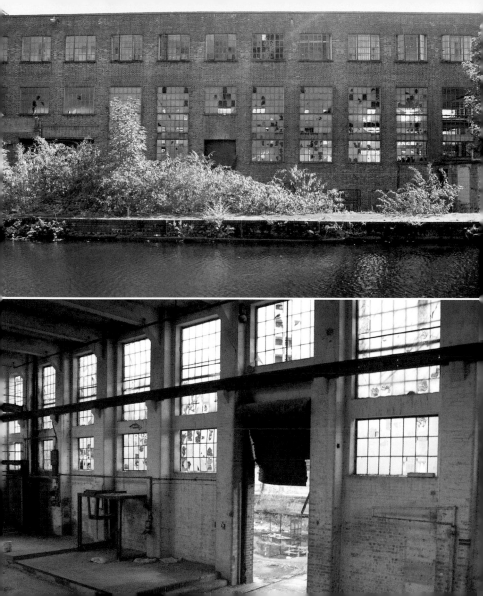

Sex Shops

The modern sex industry has existed in Soho for over 50 years, reaching its apogee in the late 1960s and 1970s when every street seemed to house film clubs, strip joints and mail order and retail shops. Recently, however, the council has been clamping down, compulsorily purchasing premises thought to house brothels.

Plans are afoot for this row of shops, involving the construction of a new building that will have retail outlets on the ground and basement floors and 15 residential units above.

TOTTENHAM HIGH ROAD N15

DISS STREET E2

PRINCE OF WALES

ORCHARD PLACE E14

Eating and Drinking

Pubs and Cafés

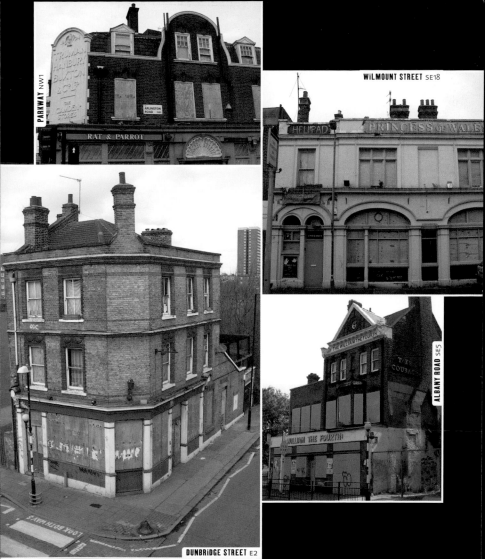

PARKWAY NW1

RAT & PARROT

WILMOUNT STREET SE18

HELIPAD PRINCESS OF WALES

ALBANY ROAD SE5

THE WILLIAM THE FOURTH

WILLIAM THE FOURTH

DUNBRIDGE STREET E2

The Intrepid Fox

Soho W1

The Intrepid Fox gets its name from the eighteenth-century political wheeler and dealer Charles James Fox. Some claim that he once promised free beer to anyone who offered him electoral support, but it seems more likely that it was the original owner of the pub, Mr House, who made this offer in order to promote his friend's cause. In more recent times the pub became the favourite watering-hole of London's rock elite and a big tourist draw. Mick Jagger and Rod Stewart are rumoured to have come close to trading punches here after the former tried to poach Ronnie Wood – then in Stewart's band the Faces – for the Rolling Stones. The late hell-raising actor Richard Harris was also a regular.

Everybody was dismayed when this historic piece of Soho was closed down in the autumn of 2006. Malcolm McLaren, who used to drink at the Fox with Johnny Rotten and the other Sex Pistols in the 1970s, backed an unsuccessful campaign to save the pub, having once named it one of the five best in the world. An ex-landlord comments on the closure: 'It is another step towards the homogenization of Soho as just another bland, faceless area.'

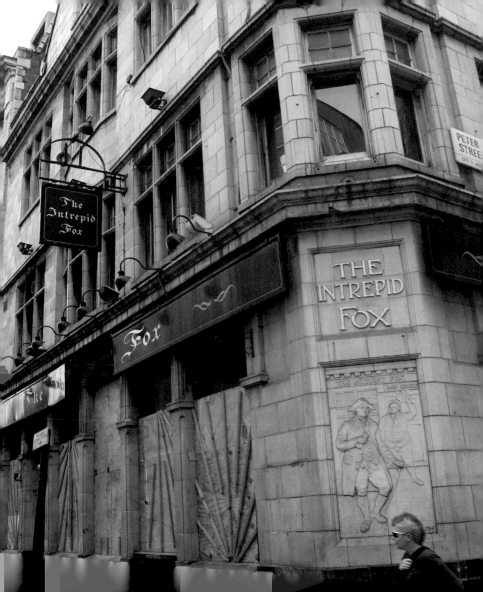

Brady's Bar

Brixton SW9

Originally called The Railway Hotel, this building dates back to 1880, according to a commemorative stone (laid by one Annie Allen) built into the fabric.

The Railway Hotel had a long association with music and dance. In the 1960s Jimi Hendrix was reputed to have regularly jammed here after playing in the West End. It also features in the film *Rude Boy* by the Clash. Renamed Brady's in the 1990s, it continued to play an integral part in the local music scene, with bands such as Alabama 3 regularly putting on shows. Squatters then took over for a while, putting on further events until evicted in 2002.

The building has remained derelict ever since the squatters left, and the clock tower has been defaced with graffiti.

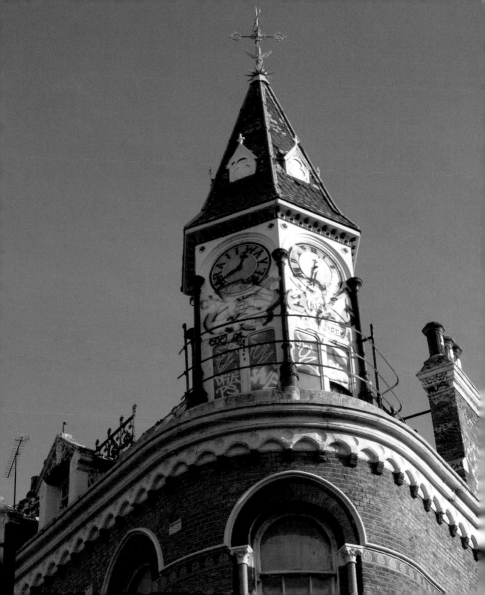

The Antigallican

This early to mid-nineteenth-century pub derived its name from the Anti-French societies that sprang up in London during the Napoleonic Wars.

The pub has now been partly demolished and all that remains is the facade, which is dominated by the massive redevelopment of Tooley Street. A security guard looking after the construction site that currently surrounds the pub told me tales of his uncle meeting actor Oliver Reed here one night on a drunken pub crawl during the mid-1960s.

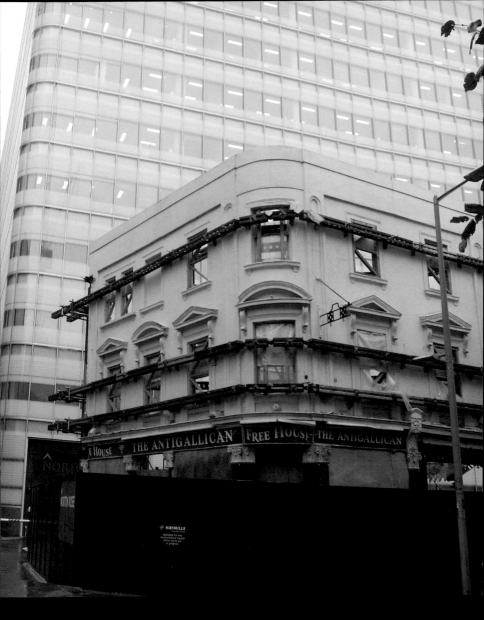

The Red Lion

Soho W1

The Red Lion has been in existence since at least 1793, though the building we now see was substantially altered in 1866. Its main historical claim to fame is that in 1847 Karl Marx and Frederick Engels held a meeting in the upstairs room of the pub and there wrote an 'action programme' for the Communist League. The programme was published in 1848 as the *Communist Manifesto*.

The pub's more recent history has been less illustrious, although in the 1990s some enjoyable poetry nights were held upstairs by the Hard Edge Club, which gained a minor cult following amongst Londoners. Finally, in 2006, the Red Lion was closed and boarded up. It is due to reopen as a 'Be at One Bar', part of a small London chain of style bars founded by three bartenders.

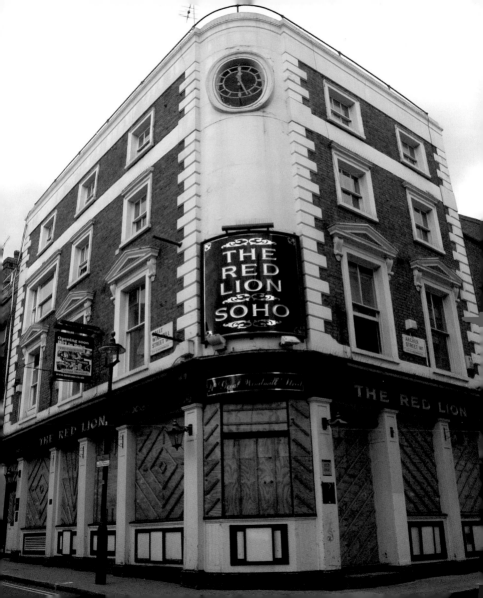

The Tea Rooms

Holborn WC1

Trendy coffee bars and US fast food chains have contributed to the gradual decline of traditional English café culture. London's 'greasy spoon' cafés are apparently disappearing at the rate of one a month, while the number of branded coffee shops (like Starbucks) has trebled in the last five years. The advent of chain pubs offering cheap meals has also had its effect on café culture.

Shortly after the Tea Rooms in Holborn closed for business a sign appeared in the window that read: 'The Tea Rooms has now closed after 44 years of happy trading. I would like to thank all of my customers who showed their loyal support throughout the years. I will miss you all dearly. God Bless. Mrs Reni Corsini.'

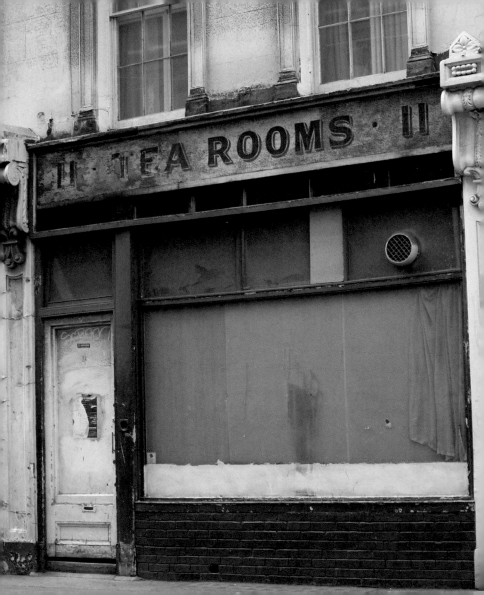

The Falcon

Despite a fire that nearly destroyed the building, the
Falcon's Barfly Club went from hosting low-key small
backroom gigs in the late 1980s to becoming one of
the most influential music venues of the 1990s. This
was *the* place to play. Coldplay appeared here in
1998, along with many other up-and-coming bands
of the day that variously became household names or
disappeared into obscurity. Crowd capacity disputes
with the local authorities, however, eventually led
to the Barfly Club moving to the Monarch in nearby
Chalk Farm.

In an earlier era, Alfred Hitchcock filmed his 1956
version of *The Man Who Knew Too Much*, starring
James Stewart and Doris Day, in this street.

The Falcon
is now being converted into apartments.

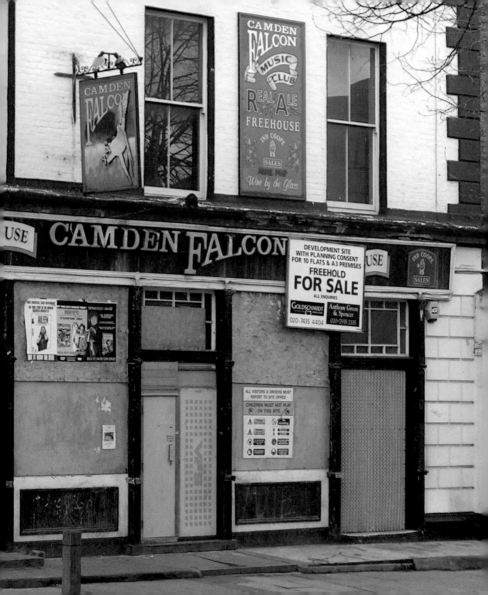

The Crown and Shuttle

Originally opened in 1851, this pub was rebuilt in its
current form in 1885 and bears a name that seems
to be linked to the Huguenot weavers who once
operated in Spitalfields.

A derelictlondon.com visitor comments
that the Crown and Shuttle was formerly a topless bar
– apparently, the girls used to come round with a pint
glass, customers put 50p in and the girls then did
a dance on the pool table. When the owner died in
2000 the pub closed and it has never reopened.
Its future is in some doubt.

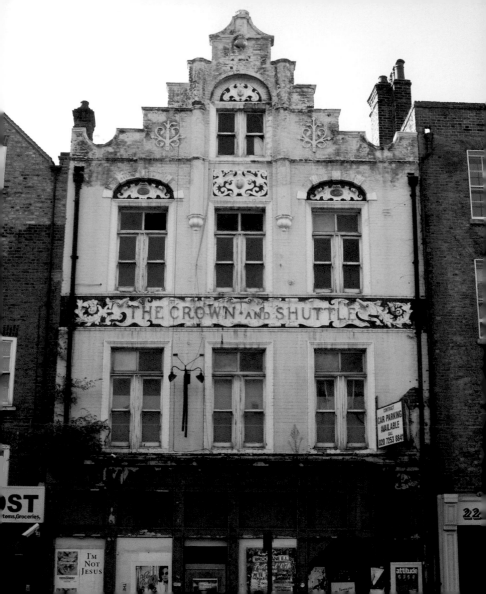

The Seven Stars

The last remaining pub in Brick Lane finally lies empty,
having limped through its final days, first as a strip
pub, then as a café-bar. It enjoyed fame briefly when
it featured in an episode of the '80s TV series *Minder*,
starring George Cole and Dennis Waterman and,
more bizarrely in 1995, when it became the venue for
a screening of a film showing the burning of £1 million
in £50 notes by the trustees of the K Foundation,
Jimmy Cauty and Bill Drummond. Around 400 people
turned up for the event, and managed to squeeze into
a basement room, but the cramped conditions proved
too much and the event was abandoned.

Quite why Cauty
and Drummond should have opted to burn £1 million
remains shrouded in mystery.

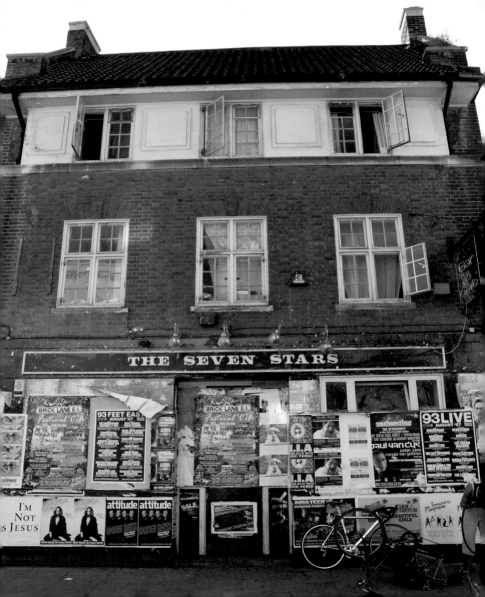

Tidal Basin Tavern

This large former public house, built around 1862, and once known as 'The Dug Out', was bombed during the Blitz, but was restored after the war and remained open until towards the end of the century, doing a good lunchtime trade with those working on the regeneration of the adjacent docks. Severe structural problems ultimately brought about its demise, with large cracks opening up on its external walls.

Back in 1963 the Tidal Basin Tavern featured in the cult film *The Leather Boys*, which combined a 'realistic picture of working class life' with rockers on bikes. The scenes filmed in the pub focus on the main character's dilemma – whether to stay with his unfaithful pregnant wife or run away to sea with his gay mate. The cast included Colin Campbell, Dudley Sutton and Rita Tushingham.

The Tidal Basin Tavern later became a venue for punk gigs which, in 1977, included Siouxsie and the Banshees. It was around that time, I have been told, that someone stuck a shotgun through the door and shot dead a man at the bar.

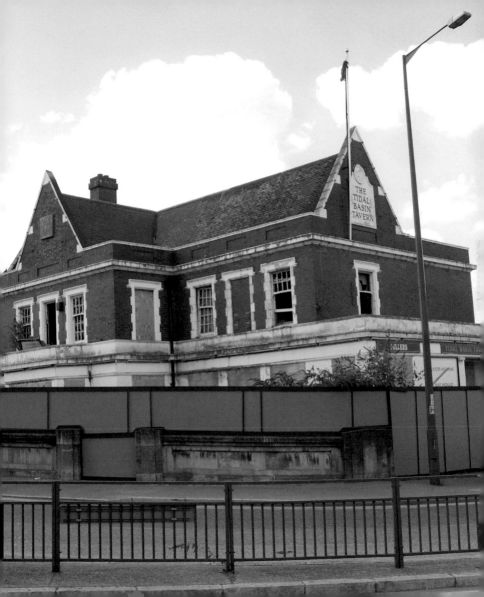

Georges Diner

Reputedly serving up the best fry-ups and home-made steak and kidney pies for miles around, and run by Brian (not George), the clientele here was a great mixture of builders, lorry drivers and Canary Wharf suits. Other attractions included showers for the drivers, cracked plastic chairs, and copies of the *Sun* and *Trucking*.

Georges Diner – they never got round to putting an apostrophe in the sign – closed down in 2005 to make way for the new Silvertown Quays development (still pending).

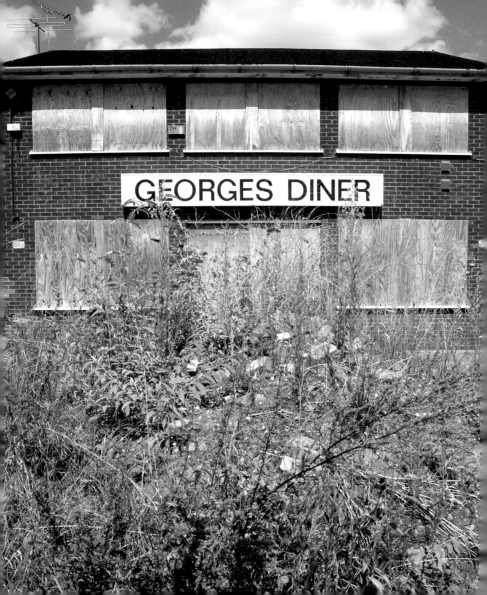

The Woolwich Infant

The Woolwich Infant on Plumstead Road was named after a huge gun that was built in 1872 at Woolwich Arsenal for HMS *Devastation*. The story goes that when the gun was fired for the first time the resulting detonation cracked the barrel.

Rather more successful in the field of marksmanship was Billy Dunbar from the pub's darts team. He was a finalist in the National Darts Championship in 1984.

I originally photographed the exterior of this decaying pub five years ago, only to discover upon closer inspection that it was actually open. If the outside was grim, the inside did not leave much to be desired either. However, the pub later had a makeover and became a very popular venue for the local gay and lesbian community. In 2006 a fire wrecked the interior and the pub has remained closed ever since. It still looks better now than the first time I saw it ...

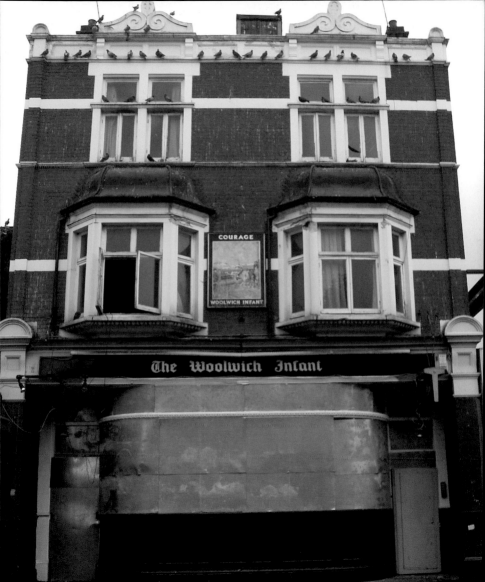

The Flying Scud

The Flying Scud was apparently named not after a missile but a famous racehorse. There was, however, also a clipper of this name, and in the 1980s the pub had a sign outside depicting a ship. The long-forgotten 1866 play *Flying Scud*, incidentally, is said to have given rise to the expression 'going to see a man about a dog', used to avoid revealing the true nature of one's business.

The pub has had a fairly rough history. I have been told of a stabbing that took place there shortly after the Second World War and it finally closed in 1994 after a police siege involving an armed gang. According to a cab driver I spoke to the pub's scorched appearance has nothing to do with the siege, however, but came about when a film crew who were using the Hackney Road locality to represent Belfast decided to 'decorate' the pub to make the setting more authentic.

Towards the end of its life, the Scud featured heavy metal nights and – in its final days – strippers.

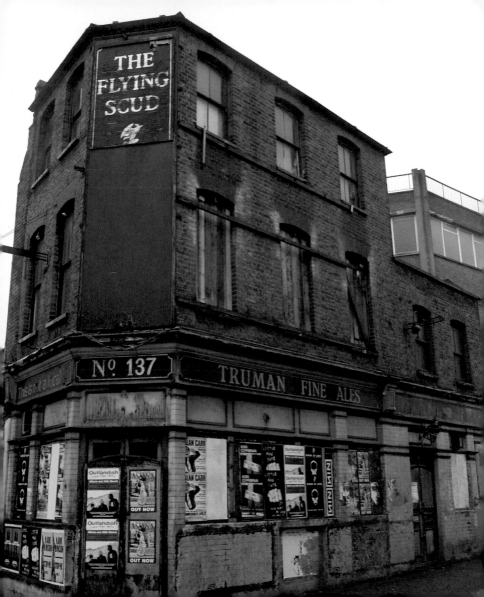

Thomas a Becket

Medieval pilgrims travelling from London to the tomb of Saint Thomas a Becket in Canterbury would have made their first stop close to this spot. Centuries later, in 1888, a suspect in the Jack the Ripper murders was arrested coming out of a nearby pawnbroker's shop, having left behind a bag containing a dagger, a knife and two pairs of very long scissors. And more recently, the Thomas a Becket housed a boxing gym on the first floor, frequented by all the top names in British boxing, among them Henry Cooper. The body-builder Dave Prowse (probably better known as the original Darth Vader) was photographed here with Muhammad Ali. In the early 1970s David Bowie rehearsed on the second floor and wrote *Ziggy Stardust*, while James Fox trained in the boxing gym for his part in *Performance*.

Until recently the ground floor was used by an estate agent, but it is now vacant. Another part of the building is used as an art gallery. Local lore insists that one of the rooms is so heavily haunted that no one can spend more than five minutes in it before fleeing in terror. Whether the ghost is a murdered archbishop, Jack the Ripper or a boxer is not recorded.

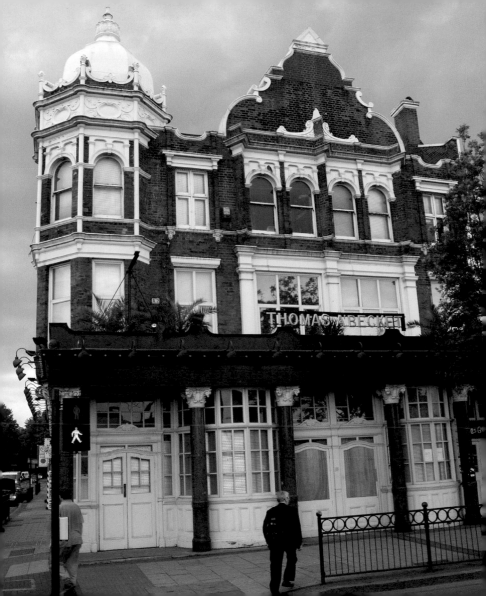

Sir George Robey

A few years back the Sir George Robey (named after the famous music-hall comedian) was an infamous, mainly punk, rock venue. During the late 1980s this place was *the* venue for any up-and-coming band with a Ford Transit on the 'toilet circuit' up and down the country. Bands playing here in the late 1980s included Blur, Hawkwind, the Jesus and Mary Chain, Steve Marriott, Gong, Snuff and the Exploited. Everybody seemed to have a love/hate relationship with the place. It certainly attracted great bands, but it was also none too salubrious at times – I remember watching the singer TV Smith slipping over someone's vomit whilst onstage. It was taken over by the Mean Fiddler Group in the mid-1990s and renamed the Powerhaus, but that did not last too long and the venue closed down.

After a special screening of *Fever Pitch* in Brixton, Nick Hornby confirmed to a derelictlondon.com fan that the Harry Lauder music venue in his novel *High Fidelity* was based on the Sir George Robey.

At the time of writing, the venue is being totally gutted by builders.

Matthiae Café

This was a once-bustling business with a classic blue and silver Art Deco shopfront and matching interiors, which recently earned the building grade II-listed status. Reg Matthiae opened the venture as a bakery in 1920 and subsequently expanded the business to include a café, restaurant and catering service.

The building boasts several attractive features, including a glass ceiling in the shop – a cause for concern during the Blitz when any serious vibration could have brought it down on top of staff and customers. As if to compensate for this, the staircase that leads to the first floor is so solidly built that it served as an air raid shelter. Upstairs there is a banquet room and, on the top floor, an Art Deco ballroom.

The family business closed in 2001 after 80 years. The building has been empty ever since and has suffered from a lack of general maintenance. A few old wedding cake decorations covered in dust remain visible in the window.

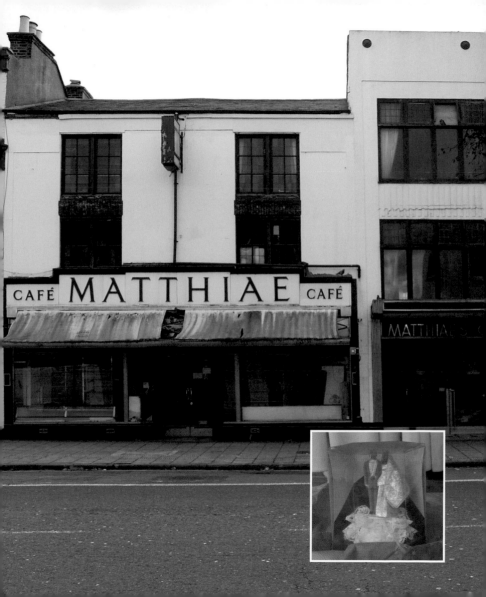

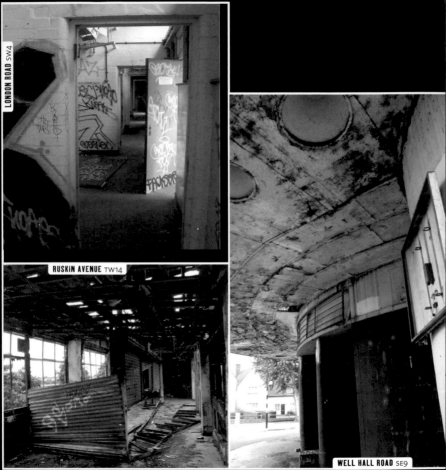

LONDON ROAD SW4

RUSKIN AVENUE TW14

WELL HALL ROAD SE9

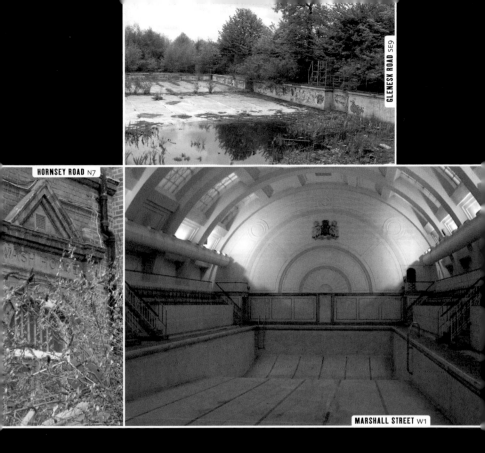

GLENESK ROAD SE9

HORNSEY ROAD N7

MARSHALL STREET W1

Relaxing

From Public Baths to Cinemas

Severndroog Castle

This triangular-shaped 60-foot tall castle is the focal point of what was formerly a popular recreation area. It was built in 1784 by Lady James of Eltham as a memorial to her husband, Sir William James, and named after his most famous exploit when, in 1755, he destroyed the fleet and stronghold of pirates at Severndroog Island on the Malabar coast of India.

In 1922 Severndroog Castle and the surrounding woodland was bought by the London County Council to form a recreational area for Londoners. A small teashop on the ground floor of the castle proved enormously popular in the postwar years. Greenwich Council then took over ownership, but decided that it did not have the resources to maintain the building. Castle and tea-shop closed and were boarded up in 1988.

Since then the building has been subject to vandalism and decay. A proposal to lease the castle to a property developer, who intended to convert it into offices, was met with furious opposition from campaigners. The Severndroog Castle Building Preservation Trust has since been created to restore the building and open it to the public.

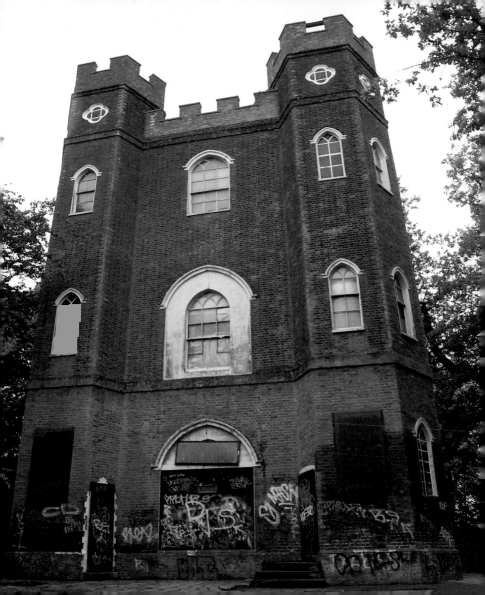

Marshall Street Baths

At the time of the Great Plague of 1665 pesthouses and a burial ground were located here. The first public baths were built on the site by the Vestry of St James in 1850. The present building, originally known as the Westminster Public Baths, was completed in 1931.

The main pool is lined with white Sicilian marble, which also appears, along with green marble, on the walls at either end. There is a bronze fountain in a niche at the shallow end, depicting a mermaid with two dolphins. Behind the pool is a smaller 'second-class' bath. The complex also included a child's welfare centre and a public laundry.

Marshall Street Baths are owned by Westminster City Council and were closed in 1997 due to 'health and safety and maintenance issues'. Plans are underway to convert the building into a residential development while retaining the main pool for public use.

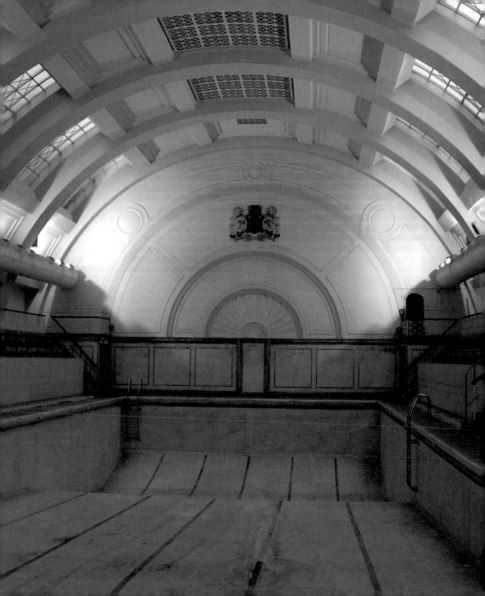

The Cinema

The Cinema in Hoxton opened in 1914 and had a capacity of 866. It was temporarily closed at the height of the Blitz, and finally shut its doors in 1956, a victim to the rival claims on people's attention of the up and coming world of television.

The building lay empty for four years, and was then used as a meat storage facility until 2001. Now derelict, plans are underway to reopen it as a four-screen cinema, with office space bolted on above. Whether the scheme will be successful remains to be seen: some local residents have pointed out that poor attendance drove the last new cinema project in the area (the Lux in Hoxton Square) out of business, and that there is a rival cinema close by on Bethnal Green Road.

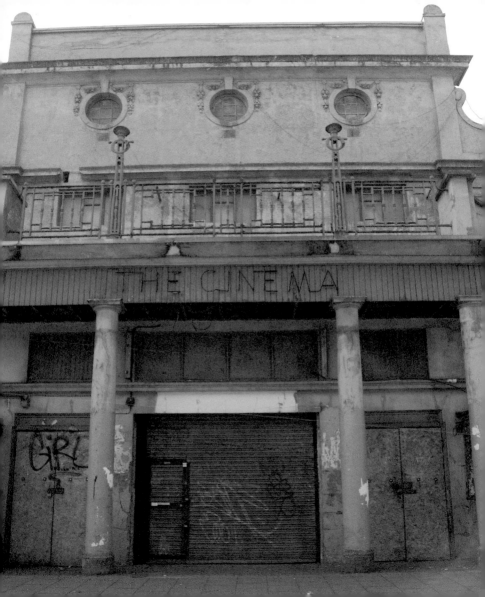

Crystal Palace

Sydenham SE19

The Crystal Palace was a huge glass and iron structure originally built in 1851 for the Great Exhibition held in Hyde Park.

Once the exhibition closed, the Palace was moved to Sydenham and reopened by Queen Victoria. It boasted two huge towers – higher than Nelson's Column in Trafalgar Square – and numerous fountains, and it became the world's first theme park, staging displays, festivals, a rollercoaster, cricket matches and 20 FA Cup Finals. The gardens even included a prehistoric swamp, complete with models of dinosaurs – the first such prehistoric reconstructions ever made. The dinosaur park is still there.

Sadly, Crystal Palace's history has been one of disasters and neglect. The original operating company found the site too large to manage and went bust in 1911. Then, in 1936, a disastrous fire swept through the main building. Only the towers survived the blaze, but they were then demolished during the Second World War when it was feared that they would act as landmarks for enemy bombers. Crystal Palace's fortunes have not improved since.

Crystal Palace Sphinxes and Aquarium

Crystal Palace's slow decay is evident everywhere. Surviving remnants of the building are now disappearing in the undergrowth. Only the terraces with their crumbling sphinxes are there to remind visitors of former glories. What was once the world's largest marine aquarium also limps on.

It somehow seems appropriate that one of Crystal Palace's more bizarre claims to fame should also involve misfortune – it was the setting for the world's first road fatality. In 1896, 44-year-old mother Bridget Driscoll, who had come to London with her teenage daughter and a friend to watch a dancing display, was hit, while walking on a terrace at Crystal Palace, by a car travelling at 'tremendous speed' (the driver was reported to be doing 4 mph). At the inquest, the coroner said: 'This must never happen again.'

Plans are now afoot to transform and regenerate the area.

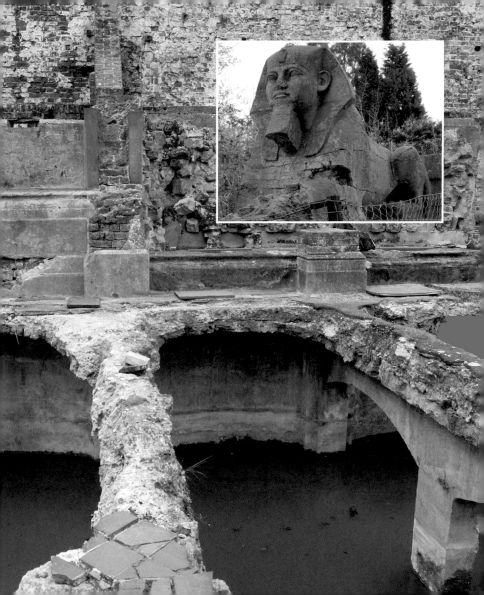

EMD Cinema

Walthamstow E17

Built in 1930 by Granada boss Sidney Bernstein, this was one of the group's flagship cinemas. Conceived on a lavish scale, the exterior was designed by Cecil Masey, while the interior was the work of Theodore Komisarjevsky, a refugee Russian prince, both working in an opulent Moorish style. Foyers were lined with mirrors; gilding and marble effects were used everywhere.

During the 1960s the building also hosted gigs by the Who, the Rolling Stones and the Beatles, among many others. A few years back the footballer Bobby Moore was spotted here by one derelictlondon.com correspondent, apparently looking for the cinema's handyman who had been a childhood friend in Barking and who had often visited the cinema with Moore.

The cinema finally closed in 2003. It still has its Christie organ, which has reportedly suffered only minor damage at the hands of vandals and the rear ends of pigeons.

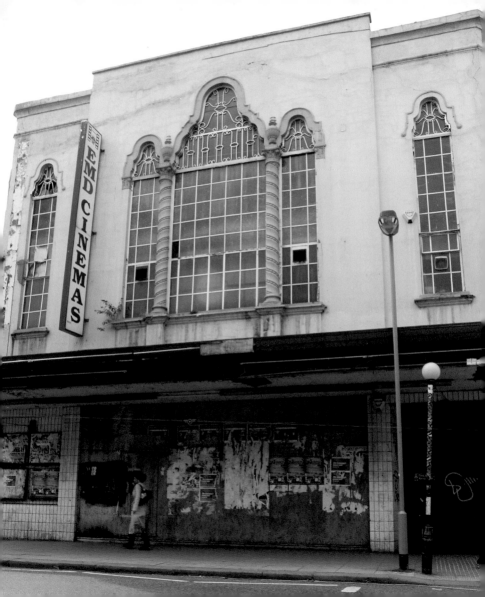

Poplar Baths

Poplar Baths were originally opened in 1852, following
the Baths and Wash Houses Act, and were rebuilt on
the same site in 1933. Part of the building, known as the
East India Hall, was used as a theatre (capacity 1,400),
dance hall, exhibition room and sports hall, especially
for boxing and wrestling. Local opinion was not
favourable: the building was dubbed 'Poplar Gaol'.

Wartime
bomb damage forced the closure of the hall until 1947,
but the venue revived after the war, attracting almost
a quarter of a million swimmers each year in the later
1950s. Then decline set in, the building started to
show its age, and when in 1985 problems were found
with the roof, the baths closed for good.

The statue in front
of the building is that of Richard Green, a Victorian
shipbuilder, shipowner and local philanthropist.

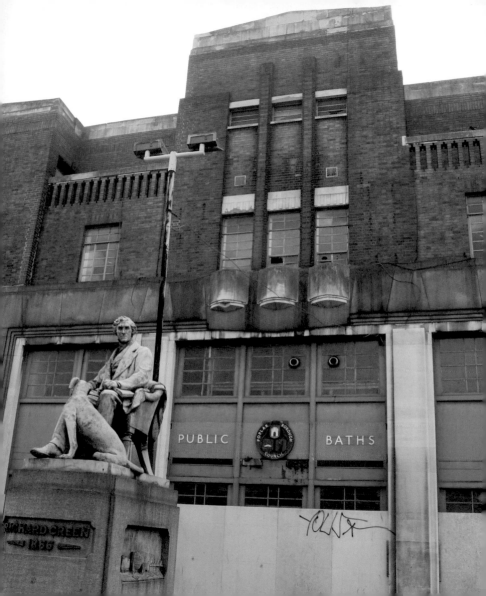

The Play Tower

This unusual red-brick gothic building just outside
Lewisham was built in 1884 and called Ladywell Baths.
It had two public swimming-pools – one for first-class
and one for second-class users. It also originally had a
conical roof on the tower, but this was lost during an
air raid in the Second World War.

The building was last
occupied by Ladywell Gymnastics Club, but they left
in 2004. Plans to demolish the building and construct
a secondary school on the site have come to nothing,
and the baths have recently been awarded grade II-
listed status. Whether that will save them in the long
term remains to be seen.

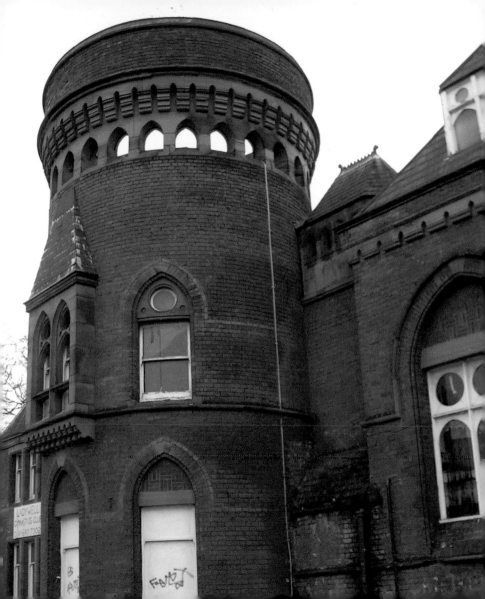

Arsenal Stadium

Highbury N4

Arsenal Stadium, known almost universally by its original name Highbury, was the football ground of Arsenal Football Club from 1913 to 2006, when the club located to the much larger Emirates Stadium.

At present the old stadium is being converted into an apartment complex, known as Highbury Square. Most of the stadium is being demolished, though the exteriors of the listed Art Deco East Stand (pictured) and the matching West Stand are being preserved and incorporated in the new development.

One bit of football trivia is in order here. The local tube station was originally called Gillespie Road but was renamed Arsenal in 1932, making it the only London Underground station to be called after a football club.

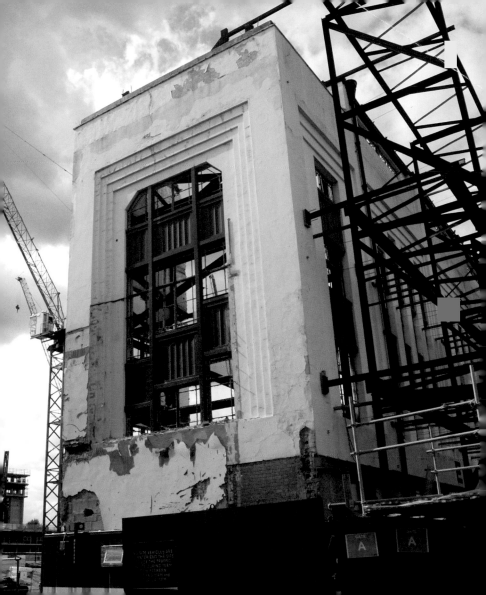

Woodford Town FC

(Snakes Lane)
Woodford IG8

In the postwar years these grounds witnessed the astonishing success of amateur football club Woodford Town – much loved by its fans, much feared by its rivals. It produced a succession of international players at amateur level. Fulham and England legend Johnny Haynes played for the club as a boy and Jimmy Greaves played at 'The Woods' before retiring altogether.

In the 1986–7 season, Town reached the first round of the FA Cup. They played in the Anglo-Italian Cup in 1986, losing 4–0 to Piacenza in the semi-final and then 3–2 to Merthyr Tydfil FC in the third place play-off.

Town moved from their Snakes Lane home in 1992 to play at Clapton's ground until being finally voted out of the Essex Senior League in 2003. The old ground is now overgrown. Only the floodlights and a rusting turnstile providing reminders of its past.

Coronet Cinema

Eltham SE9

The Art Deco Coronet Cinema opened, as the Odeon Cinema, in 1936 to serve the swelling suburban population in the Well Hall area of Eltham. It finally closed its doors in 1999 due to declining trade. Local campaigners want to see the borough's first bowling alley built on the site, while developers favour converting the building into work space, shops and a café. It is currently in limbo, prey to vandals.

Just across the roundabout from the Coronet Cinema, opposite a bus stop on an anonymous suburban road, lies a simple grey marble plaque, a memorial to a black teenager murdered by thugs in 1993. It is engraved with the simple words 'In memory of Stephen Lawrence'.

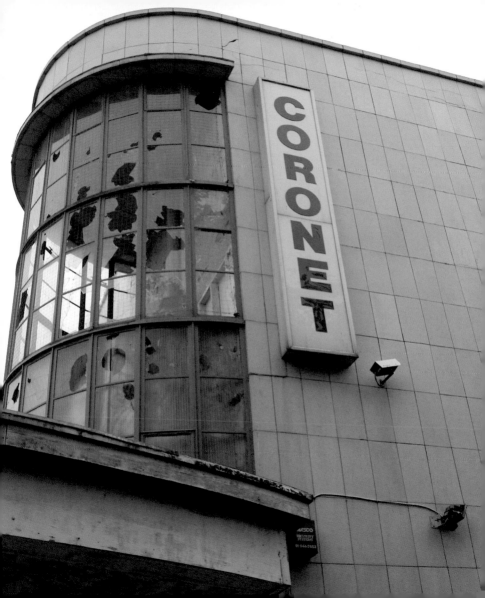

Feltham Arena

Feltham Arena was the home of Feltham FC from 1963 until 2004. The ground boasted a capacity of 10,000, of which 750 could be seated. The grandstand was officially opened in 1966 by the mayor of Hounslow.

The club played on an artificial pitch laid in 1984, though this pitch denied Feltham entry to FA competitions for over a decade, natural grass being obligatory at the time. An asbestos scare led to the stadium's roof being removed in 2000.

Following a spate of attacks by vandals the club moved from the Arena and they are now sharing a ground with Bedfont FC. At one stage rumours circulated that Brentford FC would relocate to the Arena and turn it into a 25,000-seat stadium, but it is now possible that Feltham FC will return to their spiritual home and redevelop the whole arena to include five-a-side pitches, an athletics track, a boxing club and a crèche.

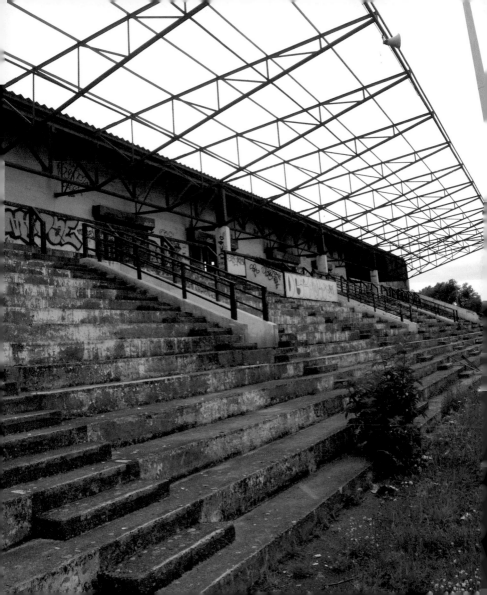

Olympics 2012 Site

The epicentre of the 2012 Olympic Games in London
will be the Lower Lea Valley in the east, where the
main Olympic stadium, aquatics centre, velodrome
and athletics village will be built. The main entrance
to the stadium will be on Marshgate Lane, where this
picture was taken.

At least 3,000 new jobs and 4,000 homes
will be generated in the surrounding areas, giving a
much needed facelift to a borough that has one of the
highest crime and unemployment rates in the country.
A number of existing houses and businesses have
been earmarked for compulsory purchase.

This building
certainly will not be here when the opening ceremony
takes place.

Hackney East Marsh

Leyton E10

East Marsh is located on the east bank of the Old River Lea and is part of Hackney Marshes. Like the rest of Hackney Marshes, it is common land and Metropolitan Open Space, used for Sunday football by hundreds of people.

When the 2012 Olympics arrive, East Marsh will be tarmaced over and used as a coach park and will be connected to the main Olympic precinct by a huge land bridge. Creating the land bridge and entrance to the coach park will mean the loss of most of the ash trees along the adjacent main road. However, after the Games, East Marsh is scheduled to be returned to football use and the trees will be replanted.

The pavilion shown here was built in July 1936 through the auspices of the Manor Charitable Trust, who were working to improve the amenities of Hackney Marsh. Damaged by enemy action during the Second World War, it was rebuilt in 1953.

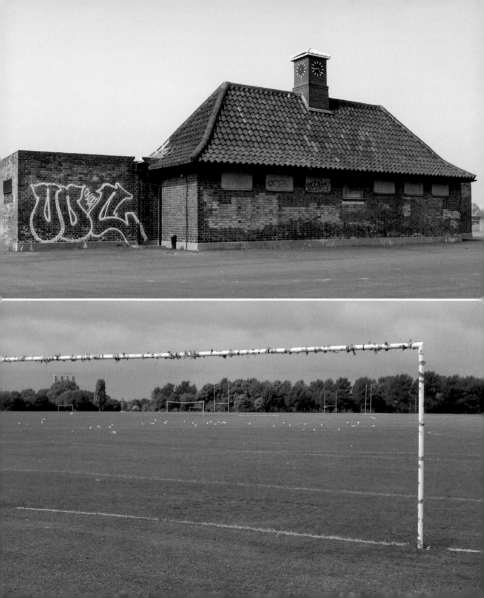

Olympics 2012 Site

Pudding Mill River E15

According to the press, the area to be transformed
for the 2012 Olympics currently comprises industrial
estates, dumping grounds and pollution. Not so well
publicised is the fact that the area is also known for its
network of waterways (the Bow Backs Rivers) and is full
of wildlife. Pudding Mill River, for example, has recently
been home to a family of swans and to pike and eel.
The black redstart, one of the UK's rarest birds, has
also been spotted in the area. The fish have now been
removed and relocated to the River Lea.

These rivers are among
the quietest places in London to walk and relax, and
while a clean-up of some parts would be welcome,
there remains the possibility that regeneration will
over-sanitise the area and destroy its character.

This river is
likely to be filled in during construction of the Olympic
stadium. Few will miss the dumped tyres, though...

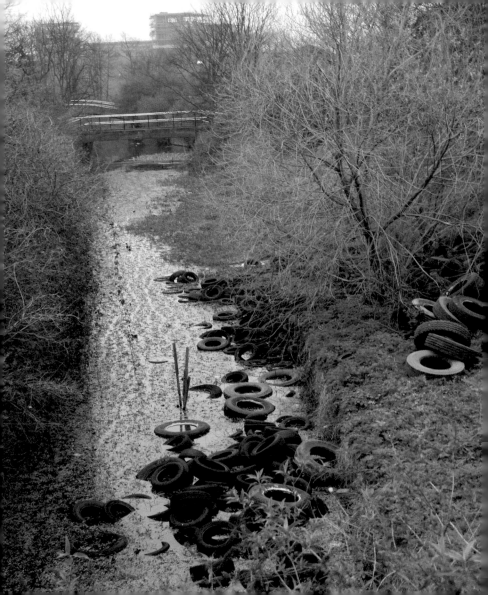

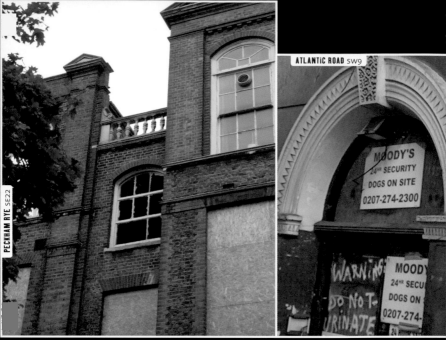

PECKHAM RYE SE22

ATLANTIC ROAD SW9

MOODY'S
24HR SECURITY
DOGS ON SITE
0207-274-2300

WARNING
DO NOT
URINATE

MOODY
24HR SECU
DOGS ON S
0207-274-

24HR

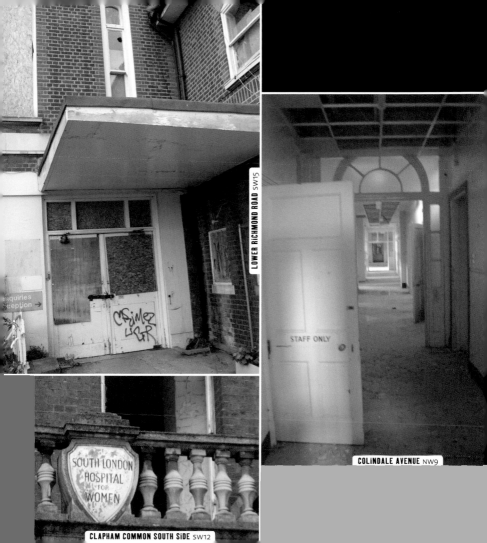

LOWER RICHMOND ROAD SW15

STAFF ONLY

COLiNDALE AVENUE NW9

SOUTH LONDON
HOSPITAL
FOR
WOMEN

CLAPHAM COMMON SOUTH SiDE SW12

Lambeth Hospital

(formerly Lambeth Workhouse)
Elephant and Castle SE11

Built in 1871, this was one of the earliest pavilion-block workhouse designs built in England and housed 820 inmates. In 1896, future star of the silent screen Charles Chaplin (then aged seven) briefly became an inmate of the Lambeth Workhouse, together with his mother and his younger half-brother. In 1922, it was renamed Lambeth Hospital.

The hospital was bombed during the Second World War, and around 20 nurses were killed; some from Ireland had only been in London for three months. Patients who were well enough to be moved were evacuated by torchlight to safer areas.

The hospital shut in 1976. The infirmary and most of the original workhouse have now been demolished, although the water tower survives. Some more modern hospital buildings at the back remain, though in a derelict condition.

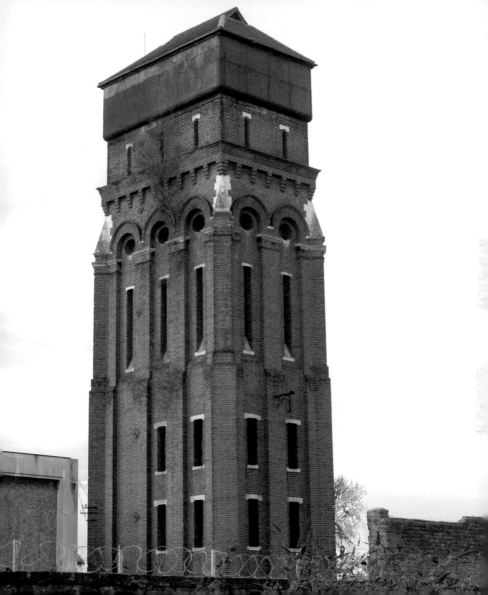

Winchester Palace

Winchester Palace, completed in the 1140s, was the London residence of the Bishop of Winchester for over 500 years. Many important visitors were entertained here –James I, for example, held his wedding banquet at the palace. It was used as a prison from 1649 to 1660 and was then leased for housing. Destroyed by fire in 1814, now only the west wall survives.

The palace was arranged around two court-yards and included a prison, brewhouse and butchery, as well as a tennis court, bowling alley and pleasure gardens for the use of the Bishop.

This picture of the remains of Winchester Palace shows its fourteenth-century rose window and the three doors to the buttery, pantry and kitchen.

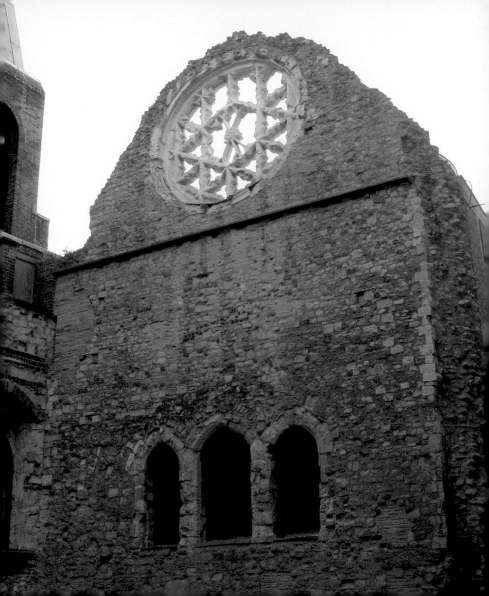

Middlesex Hospital

The Middlesex Hospital's history goes back 250 years. The Middlesex Infirmary opened in 1745 with 18 beds to provide medical treatment for the poor, and in 1747 the hospital became the first in England to add 'lying-in' (in-patient) beds. In 1757 the hospital opened on its current site, and over the years extra wings were added.

In 1924 fears that the building had become unsound led to a 'The Middlesex is falling down' campaign to raise funds for rebuilding, and in 1935, without ever having closed its doors, the new Middlesex was opened. It closed in December 2005.

There are proposals to retain some of the facades and transform the site into Noho Square – a one-billion-pound luxury homes and offices scheme. Sedum plants would cover the whole roof area.

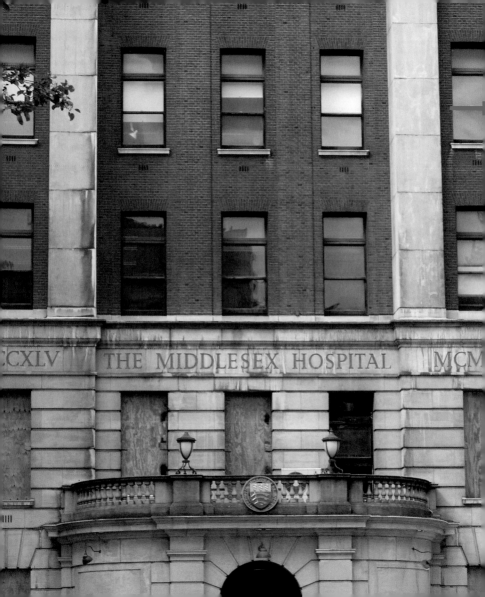

Raleigh Hall

Brixton SW9

Originally a private house called Effra House, Raleigh
Hall was built around 1840 and was later used by the
Brixton Liberal Club. In the late nineteenth century it
became a public meeting-hall, also let out for concerts
and dances. Its fall from grace is all too apparent in
this photograph.

The building featured as a crack house in
the 2001 film SW9, which was set amongst the back
streets of Brixton over a 24-hour period. The film's
cast was a cross-section of twenty-somethings with
different agendas but united by drugs, money, a love
of anarchy – and a gun.

Proposals are currently in place for the
hall to be transformed into a Black Cultural Archives
Museum, dedicated to the study and understanding
of black British history.

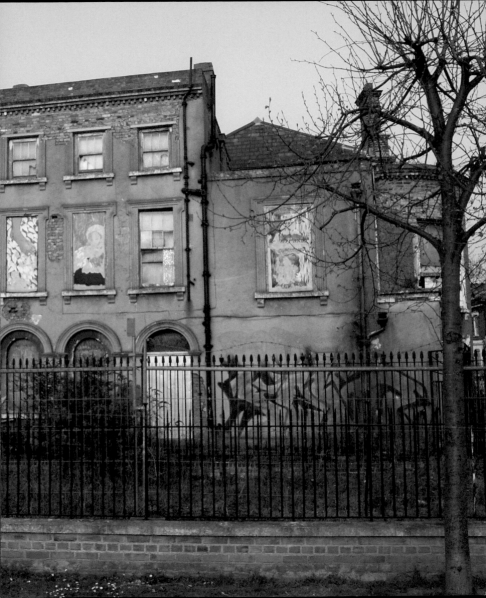

Red Telephone Boxes

The British public telephone box was the first of its
kind in the world, introduced in 1884, only nine years
after the invention of the telephone itself by Alexander
Graham Bell.

Once one of London's (and England's) defining
icons, the red public call box has been rendered
virtually obsolete by the mobile phone – British
Telecom has seen its takings from payphones fall
by half since 1999. Now uneconomic ones are being
uprooted, and it has been estimated that up to 12,000
are vanishing every year.

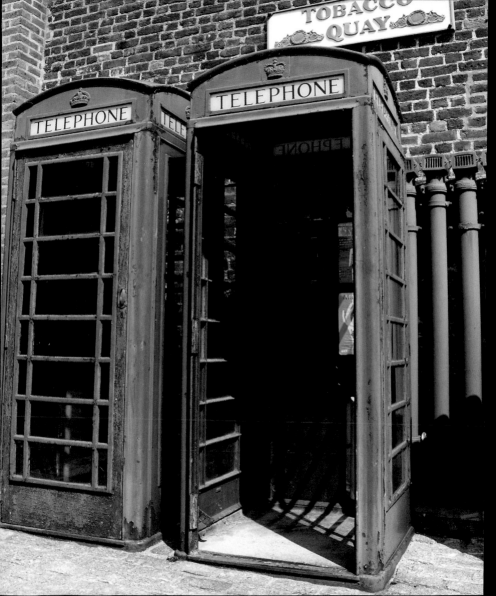

Fish & Coal Buildings and Stanley Buildings

King's Cross NW1

Once a village called Battle Bridge and, according to some, the site of a battle between Boudicca and the Romans in AD61, King's Cross's other claim to fame is that it was the first place in England where the Bessemer converter was used to turn iron into steel.

Stanley Buildings (top picture) were erected in 1864 to a design inspired by Prince Albert for ideal workers' homes and served the men working on the building of the railway in this area. A correspondent wrote to derelictlondon.com describing Stanley Buildings as they were when he lived there as a boy in 1969: 'The apartments were so old, they didn't have a bath, only the toilet bowl and a sink, no hot water. The cooking stove looked like it was from the 1800s.'

A great swathe of buildings in this area has now been cleared. The future of Stanley Buildings remains uncertain; demolition has been threatened. The Fish & Coal Buildings (bottom picture) will eventually be converted into cafés and bars.

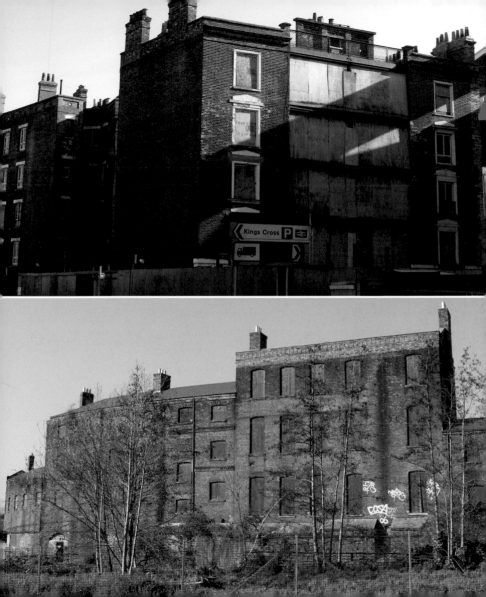

Putney Hospital

Built in 1900 and empty since 1999, Putney
Hospital's future has been complicated by questions
over where its boundaries with Putney Common lie,
and by the existence of a covenant that states that
the land, given to the people of Putney for a hospital,
must not be used for any other purpose. Latest
reports say the site has been selected as the location
for a healthcare centre.

The adjacent common is said to
be haunted by a man dressed in convict's clothing
who glides around as if intent on committing a
crime. People claim the ghost is that of a convict
who escaped from the hospital, where he had been
undergoing treatment, and who drowned in a pond
while he was being pursued.

Some scenes in the 1990 film
Nuns on The Run, starring Robbie Coltrane and Eric
Idle, were shot at Putney Hospital.

Ambulance
parking
only

Tate Institute

The Tate Institute was founded by Sir Henry Tate
in 1887 for workers in his nearby sugar factory, to
serve as a non-sectarian and apolitical meeting
place. It had a large hall and several meeting rooms,
a reading room, a billiard room and nine bathrooms.
Sir William Tate donated £1,500 to renovate the
Institute in 1904, adding another £1,200 to endow
it two years later.

The Institute closed in 1933 and the building
was sold. The top floor served as the Silvertown
Library from 1938 to 1961, while the ground floor was
used for social events for Tate & Lyle employees at the
factory opposite.

The factory is still open but the Institute is
boarded up and its future uncertain.

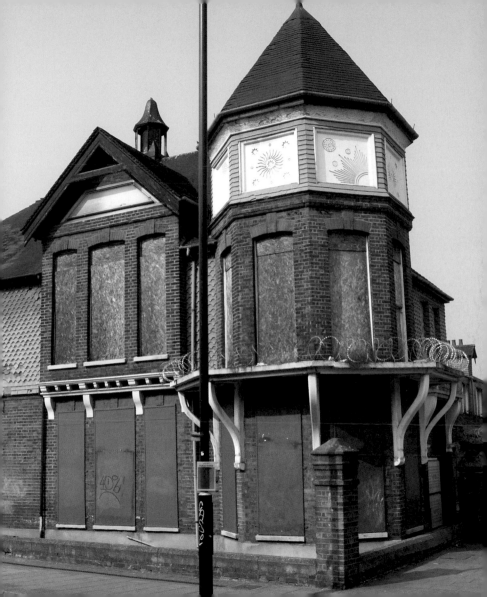

Public Toilets

Poplar E14, North Woolwich E16
Gypsy Hill SE19, Deptford SE8

Nothing is sacred in the ever-changing landscape of London, especially in the face of today's high property prices. According to the British Toilet Association, a pro-toilet lobby group, a third of the lavatories run by city councils have closed in the last five years. There is now only one public toilet for every 10,000 people in England, they say.

Many public toilets were created in Victorian times and little has been done to improve them, since they are a discretionary service that councils are under no obligation to provide. Street urination is on the increase and hand-washing facilities are ever harder to find.

Many public loos occupy prime sites, and local councils have found themselves sitting on a valuable asset (as it were). Some nearer Central London have been converted into bars and beauty salons.

Britain's public toilets are clearly an endangered species...

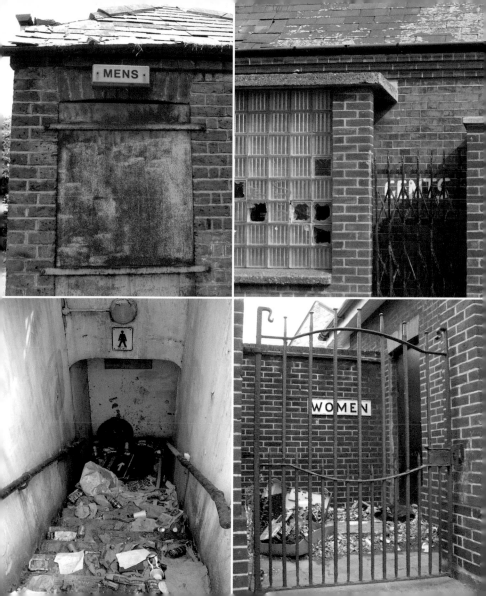

Friern School

Friern School opened in 1896 as a primary school for girls and boys. It was later to become a secondary modern called Friern Girls High School.

In 1978 the High School amalgamated with Honor Oak Grammar School and became known as Waverley School, which remained open until 2002. A fire destroyed much of the building shortly afterwards.

The plan now is to demolish most of the building, although the school's Victorian facade will be preserved. A new school (the Harris Academy) for 950 boys is to be built on the site and to be sponsored by Lord Harris of Peckham.

London Park Hotel

This hotel opened in 1897 as a Rowton House, one of
a chain of hostels built by the Victorian philanthropist
Lord Rowton to provide decent accommodation for
working men in place of the squalid lodging-houses
of the time. George Orwell wrote about Rowton
Houses in *Down and Out in Paris and London*.

The hostel was
refurbished as a tourist-class hotel in the early 1970s.
A woman who worked as a bar attendant here in 1986
wrote to derelictlondon.com about a possible haunting
in the building, saying she was woken up in the early
hours one morning by an unexplained and terrifying
screeching sound and a thumping noise in the corridor.
In the late 1990s the building was used as a hostel
for refugees, gaining a degree of notoriety for gang
violence and petty theft.

After the hostel closed around 2002,
the building was used by the BBC for 26 weeks in
the filming of the television series *Hustle*. It is now
scheduled to be demolished to make way for a major
redevelopment of the whole Elephant and Castle area.

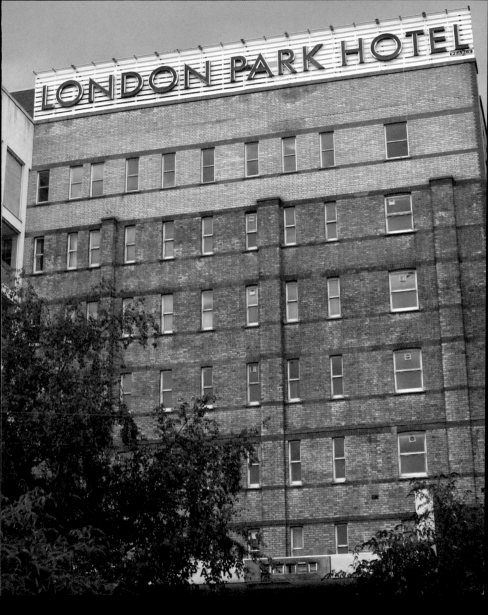

Colindale Hospital

Colindale NW9

Originally named the Central London District Sick Asylum, the hospital was built in 1898 at a time when Colindale was largely still open countryside. The central administrative block (pictured) contained offices, nurses' rooms, the boardroom and chapel, with kitchens and laundry to the rear.

In 1920 the hospital was taken over by the Metropolitan Asylums Board as a sanatorium for advanced TB cases. It was hit by V1 flying bombs on 1 July 1944, and four members of the Women's Auxiliary Air Force were killed. In 1948 the hospital joined the new National Health Service and was renamed Colindale Hospital.

The hospital officially closed in 1996. A few buildings are still used for elderly mental health patients, but most of the hospital is now derelict and its future is far from clear.

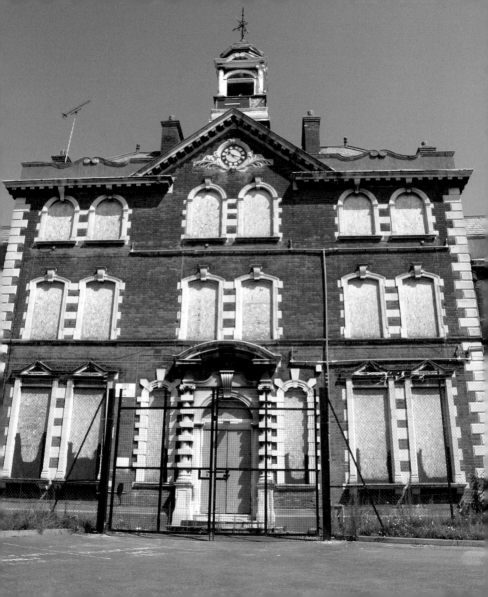

Fire Station

Built in 1903 this fire station replaced an earlier 1868
station on the same spot.

I have been told that in the basement
there is a plaque recording that this was the site of
St Thomas à Watering, the first stop for medieval
pilgrims bound for the shrine of St Thomas à Becket
in Canterbury, where they could find water for their
thirsty horses. The well they drew from is now buried
far underground. Hangings apparently also took
place here.

The fire station has been disused since 1971.
Part of the building now houses a second-hand shop
(the largest antique fireplace showroom in the world,
so it is claimed). Note the old fire station dummy in
the window.

Driscoll House Hotel

This building opened as Ada Lewis House in 1913, one of the first of a small number of places in London providing accommodation for women (although over the years male guests were also allowed). The opening ceremony was performed by Princess Louise, Duchess of Argyll, and the building was named after Ada Lewis, wife of the philanthropist Samuel Lewis.

The building was bought by Terence Driscoll in the 1950s, who renamed the building after himself. He worked every day at the hotel reception and used to give a weekly speech in the hotel at Sunday lunch, in the course of which he passed on news from past residents as well as his opinions on current affairs. Every December, Mr Driscoll would dress up as Father Christmas and distribute presents while carols were sung.

Terence Driscoll continued to be active in the running of Driscoll House until the last weeks of his life. He died in July 2007 and the hotel closed soon afterwards. There is a plan to convert the building into apartments.

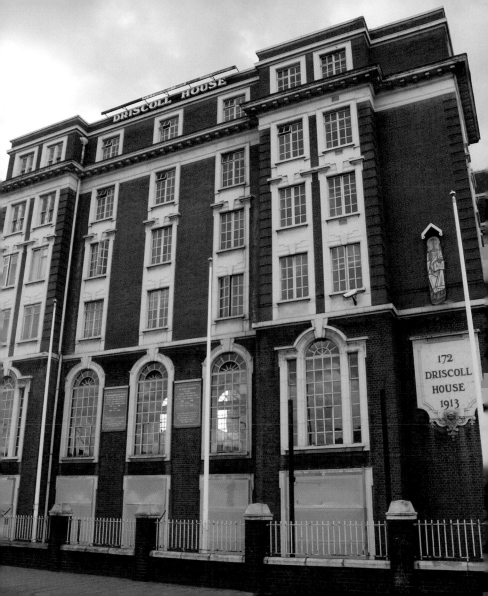

West Middlesex Hospital

Originally opened as the New Brentford Workhouse
in 1902, the buildings became the West Middlesex
Hospital in the 1920s.

During the 1990s the hospital cared
for more than 124,000 out-patients a year, as well
as dealing with 16,000 planned admissions and
delivering, on average, five babies a day. But the
dilapidated Victorian buildings were proving expensive
to maintain and were felt to be adversely affecting
the level of care on offer. In 2003 the existing hospital
closed and new hospital buildings were built adjacent
to the site. Some of what is left will be redeveloped,
while other parts will be pulled down for housing
development.

Greengate House

Greengate House was built in 1919 for the YMCA and
later, when owned by the University of East London,
was used by students.

Somebody who was a student at the
university told me that the original features have
survived largely unscathed inside, apart from the
addition of a few plasterboard walls. In the basement
is a trapdoor: when opened this reveals a fully tiled
swimming pool, complete with shallow and deep ends.
From the top floor you can see the Boleyn Ground, the
football stadium of West Ham United.

A planning application
has been submitted to keep the facade but build an
extension providing up to 90 homes for key workers
such as nurses and teachers.

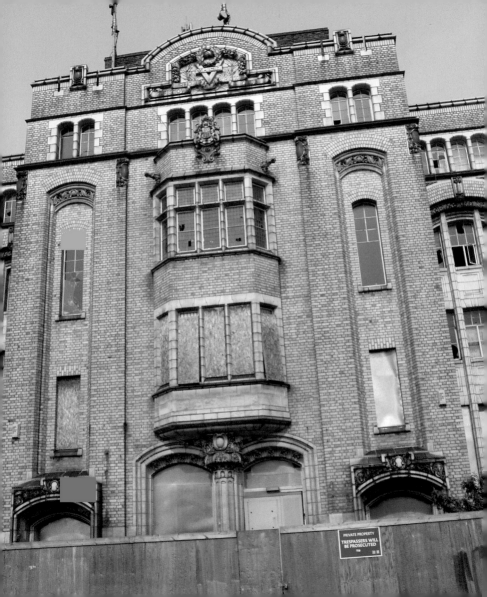

PRIVATE PROPERTY
TRESPASSERS WILL
BE PROSECUTED

P & O Building

City of London EC3

Built in 1969, with 15 storeys above ground and three below, this building was considered at the time to be one of the most complex glass-fronted structures in England.

It was extensively damaged by a Provisional Irish Republican Army bomb attack in 1992, and subsequently had to be reclad. Now it is being demolished to make way for a much taller, 48-storey tower, destined to be the tallest building in the City until the completion of the neighbouring Bishopsgate Tower. The distinctive wedge-shaped profile of the new building has already led to it being nicknamed the Cheese Grater. The project is costing £286 million.

The demolition procedure for the old building is unusual, being conducted from the bottom upwards, rather than the other way round, leaving the building's concrete core exposed. This is because of the unique way in which the building was constructed: the floors are supported by a beam hanging from the roof rather than being supported by columns from the ground.

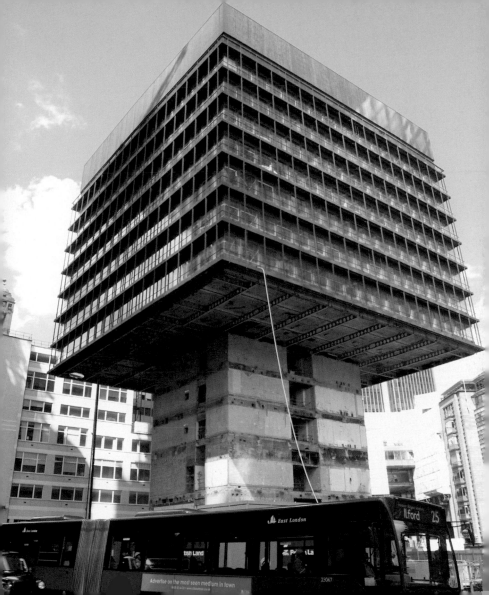

BERMONDSEY SE16

SLADE GREEN DA8

Caution for the Next
Half Mile.
This Road is in Disrepair
SLOW DOWN

WHITE HART ROAD SE18

Travelling

From Boats to Trains

Deptford Creek

Today Deptford is overshadowed by nearby Greenwich, but it, too, has played an important part in London's history. A fishing village in the Middle Ages, it witnessed the Battle of Deptford Bridge in 1497 on a site adjacent to Deptford Creek when Cornish rebels under their leader Lord Audley were soundly beaten by the king's forces. A few years later Henry VIII created a royal dockyard here, and it was at Deptford that Elizabeth I knighted Francis Drake on board the *Golden Hind* on his return from circumnavigating the globe in 1580. The *Golden Hind* remained moored in the creek until it broke up. Later still Captain Cook's ships *Resolution* and *Discovery* were equipped at Deptford before his voyages to the Pacific.

Deptford's fall from grace has been dramatic, although regeneration of the area is now underway. In the meantime the abandoned industrial landscape has produced a lively local wildlife habitat.

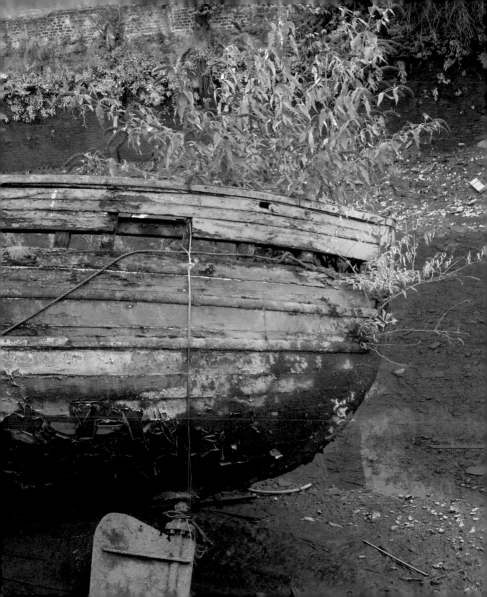

Spa Road Railway Station

Spa Road station was the terminus of London's first railway, the London and Greenwich Railway, and, in fact, there are actually two disused Spa Road stations. The first, opened in 1836, was just down the road. The second one, shown here, replaced it in 1867 and was renamed Spa Road and Bermondsey in 1877. It was closed during the First World War due to staff shortages, and, because it had never attracted many passengers, was then never reopened.

Remains of the old platforms can still be seen from trains passing between Deptford and London Bridge. In 1999 a train from Dover to London Charing Cross collided with a train from Brighton to Bedford at Spa Road, causing both to derail. Four people were injured, and a number of passengers had to be evacuated through the old station.

The arch shown here displays the signage of the South East & Chatham Railway; some of the bricked-up ticket windows are also visible.

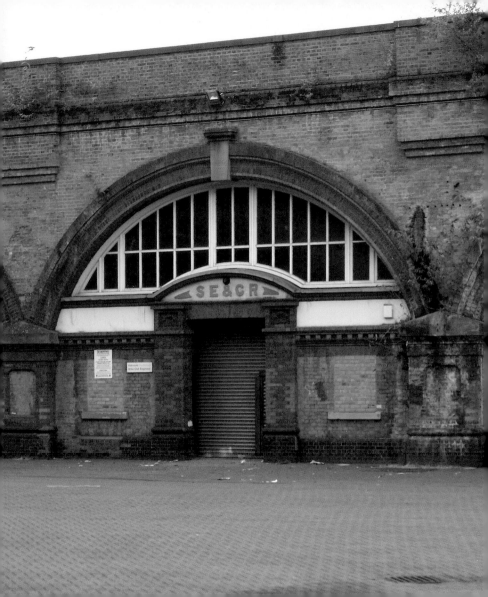

Necropolis Railway Station

As its name implies, this station served an unusual train service that operated from Waterloo to Brookwood Cemetery, near Woking: it conveyed the deceased, accompanied by their mourners, to the Brookwood Necropolis, at one time the largest cemetery in the world.

As the population of Victorian London grew at a rapid rate, and fears about public health increased in the wake of devastating cholera epidemics, the decision was taken to construct a number of cemeteries away from the centre of the city. The Necropolis was one of these. It actually had two stations, one for Anglicans, the other for Nonconformists.

The Necropolis Railway station at Waterloo suffered severe damage during an air raid in April 1941. It was never rebuilt, but the entrance and facade (pictured opposite) still survive and the building is used as offices. There is little remaining evidence of the stations in Brookwood, although the cemetery is still in use.

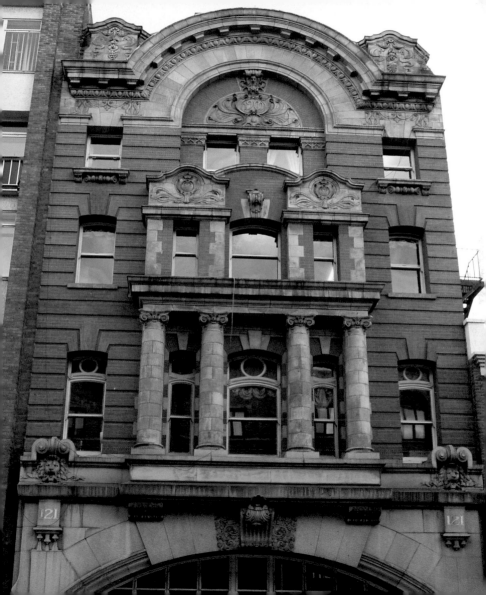

Milkfloat

The clink of glass milk bottles as they are deposited
on doorsteps and the hum of the milkfloat pulling
away at the crack of dawn is pretty much a thing of
the past in London. Cheap milk in supermarkets and
superstores means that many people are no longer
attracted by the idea of having pints of milk dropped
off on their doorstep every morning.

They probably also
reckon that bottles of milk get stolen.

Gull Lightship

Grays is not *quite* within the London area, but an honourable mention should nevertheless go to this poor ship moored on the Thames since 1947. She was built in 1860 and was in service with Trinity House for 80 years (Trinity House being the official General Lighthouse Authority). Believed to be the second oldest surviving lightship in European waters, she was attacked in 1941 by enemy aircraft and spent the rest of the Second World War laid up. She is now located next to Grays Yacht Club, who used it as a clubhouse until the 1970s.

In 2002 vandals set light to the then-restorable hulk. Since then the ship has been left to rot. She is in a sorry state. The next storm may well be her last.

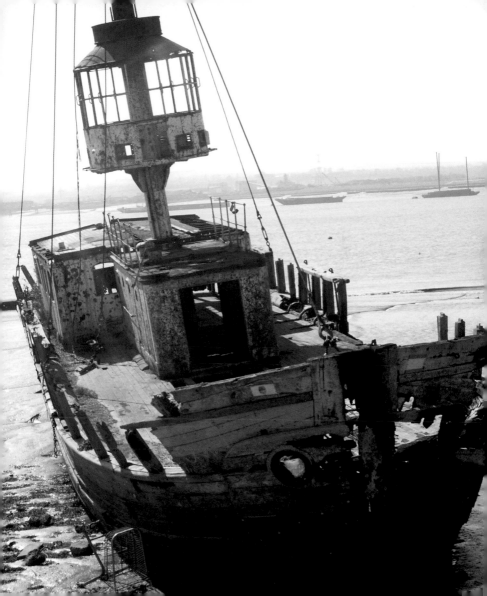

Sydenham Hill Wood

Sydenham Hill Wood forms the largest remaining tract of the old Great North Wood, which once stretched from Deptford to Selhurst. In the 1870s large Victorian villas with extensive gardens were established on Sydenham Hill, and the wood is now a wonderful mix of old and new woodland, Victorian garden survivors and even the remains of a Victorian folly (shown opposite). It is also home to over 200 species of trees and flowering plants, including wild garlic, early dog violet and bugle, not to mention various fungi, rare insects, birds and woodland mammals.

The sealed-up tunnel (inset picture) is on what was the Nunhead to Crystal Palace branch of the London Chatham & Dover Railway, opened in 1865 and closed in 1954. It is now used as a roost for bats.

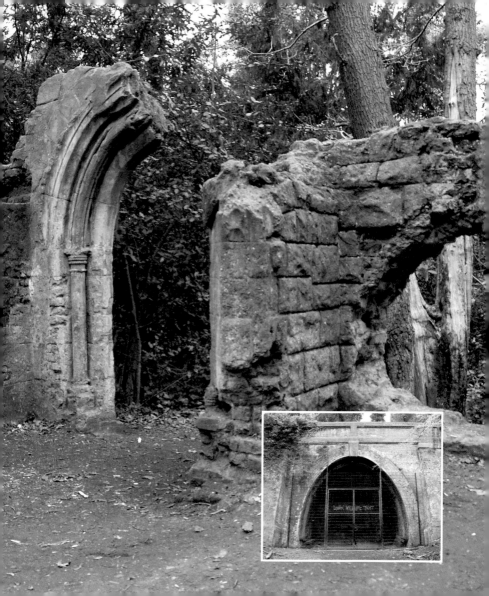

Down Street Station

This underground station was opened on what is now
the Piccadilly Line in 1907 and it closed in 1932. It was
never very busy. The well-heeled local residents tended
not to use the tube, and the area was, in any case,
already served by other nearby underground stations.

By 1939
both platforms had largely been bricked up, a concrete
cap had been fitted over the shaft, and filters and
steel doors had been installed to prevent any gas
contamination. The station was therefore an obvious
place for Winston Churchill and his wartime Cabinet
to use as a deep-level shelter until the Cabinet War
Rooms in Whitehall were completed. It then served
as the wartime headquarters of the Railway Executive
Committee.

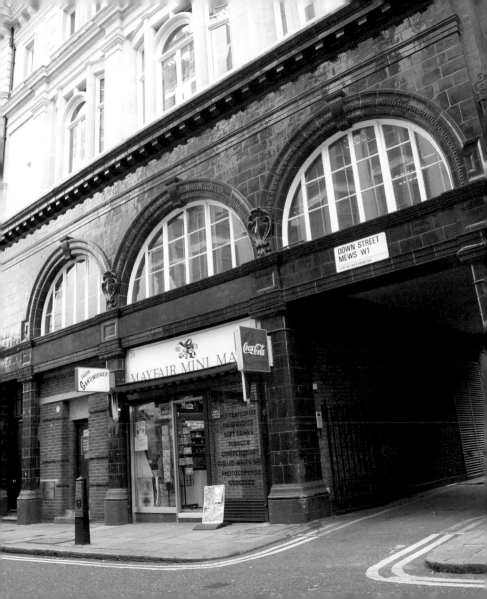

Explosion Site

Known as 'The Woolwich Abandoned Line', this stretch of railway line was used as a siding from 1855 until around 1987.

In 1917 50 tons of TNT from a nearby munitions factory, loaded into railway wagons on the track pictured opposite to await removal, were ignited by a fire in the 'melt-pot' room. A large part of the factory was instantly destroyed, and as red-hot lumps of metal were sent flying through the air, they started fires for miles around. Seventy-three people lost their lives and over 400 were injured, while the number of properties damaged has been estimated as being as high as 60–70,000. That more people were not killed was largely because the explosion took place on a Friday evening when most workers in the area had finished for the week. Some locals, quickly realising what was going on, grabbed their children and fled as fast as they could. The explosion was heard as far away as Southampton.

The inset picture shows a small memorial to the dead that has been erected near the site.

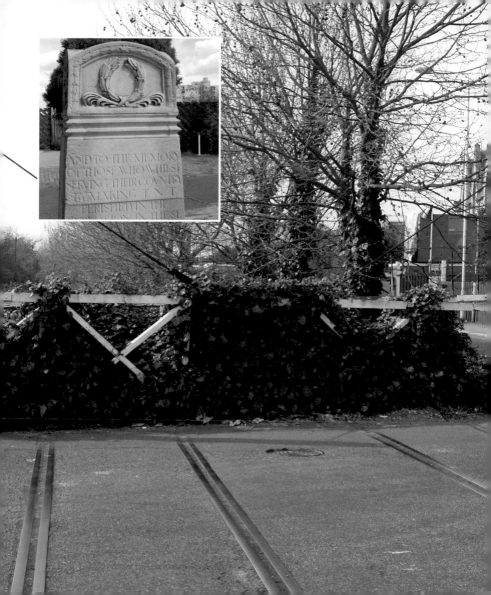

AND TO THE MEMORY
OF THOSE WHO WHILST
SERVING THEIR COUNTRY
BY MAKING T.N.T.
PERISHED IN THE
EXPLOSION IN THESE

T-34 Tank

A man bought this 32-ton Russian T-34 tank, nicknamed Stompie, for his seven-year-old son as a birthday present several years ago. It now sits at the end of Pages Walk. The council once tried to have the tank removed from the wasteland it occupies, believing it had been dumped, but then found out that the son owns the rights to the land.

The T-34 was widely considered the world's best tank when introduced by the Soviet Union during the Second World War. Over 80,000 are estimated to have been built.

Local legend claims that the tank's gun is pointed towards Southwark Council's planning offices.

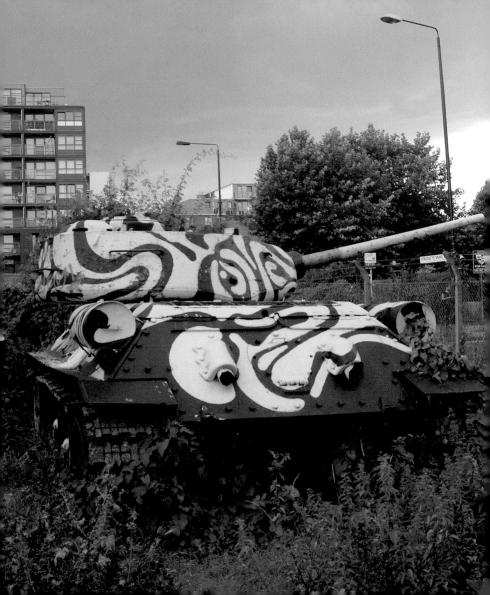

The Strand Tube Station

The Strand Tube Station, built in 1907, was the terminus of a short branch off the Piccadilly Line. It was then renamed the Aldwych to avoid confusion with the Northern Line's Strand station. The original name can still be seen on the tiling.

During the Second World War, the branch was closed and the station used as a public air raid shelter, with the tunnels being employed to store the Elgin Marbles and other precious artefacts from the British Museum. Service resumed in 1946, but ended permanently in 1994 after the cost of a lift replacement was deemed uneconomic for the 600 or so passengers who passed through every day.

Because the station was never very heavily used and was at the end of a branchline, it proved an ideal venue for film crews and it can be glimpsed in films as diverse as *Battle of Britain*, *Superman IV*, *The Krays*, *An American Werewolf in London* and *Patriot Games*. It has also represented 'Sun Hill' tube station in television's *The Bill* and appeared in *Take It or Leave It* (the film that chronicles the career of pop group Madness). The tunnel was used in Prodigy's 'Firestarter' pop video.

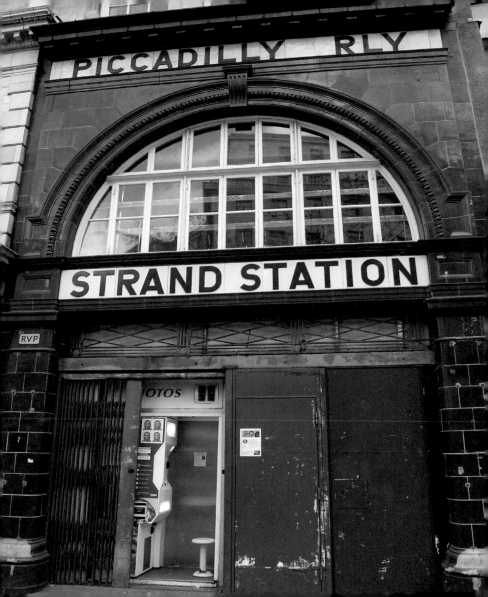

Rail Freight Marshalling Yard

Feltham TW13

This rail yard was built in 1918 by German prisoners-of-war. With its 32 miles of sidings it was the second largest yard in the country, complete with repair sheds for wagons and locomotives. However, rail traffic began to decline in the 1960s, and the yard eventually closed in 1969. It was dismantled over the following decade.

Today, it is an overgrown wilderness. There is little evidence that there was a yard here, apart from one graffiti-covered concrete building. There are a few abandoned cars, burnt out by joyriders. One car (top picture) is buried in soil and is used by local bike riders as a ramp.

Excavations on the site have revealed remains of Iron Age pottery.

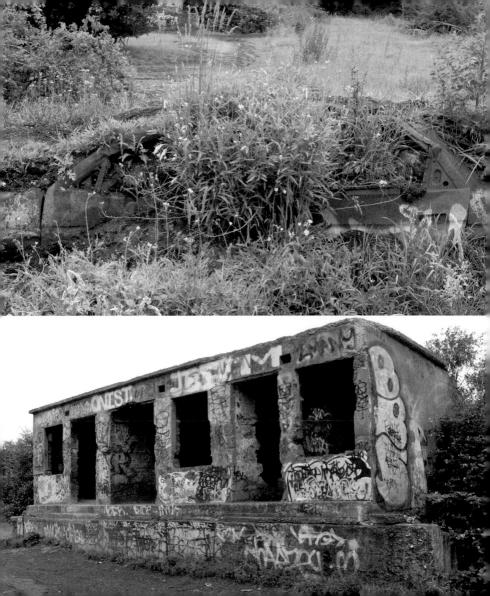

Derelict Cars

Clapham SW4 and Woodford IG8

Both of these iconic British cars were spotted in people's gardens – the Ford Cortina Mark 2 in Clapham and the Austin Mini in Woodford. The Cortina is around 40 years old, being one of the million or so made between 1966 and 1970 (very few survive today). The Mini was, of course, the most popular British-made car ever, with over 5 million manufactured between 1959 and 2000.

Apart from the fact that both cars are rusting away, they also have in common a Michael Caine connection. He drives a silver Mark 2 Cortina in the 1971 film *Get Carter* and the Mini played a key role in the 1969 cult film *The Italian Job*.

Over a third of the 220,000 cars dumped nationally each year are dumped in London. The fall in scrap metal values has meant that people now have to pay if they want to dispose of their cars legally.

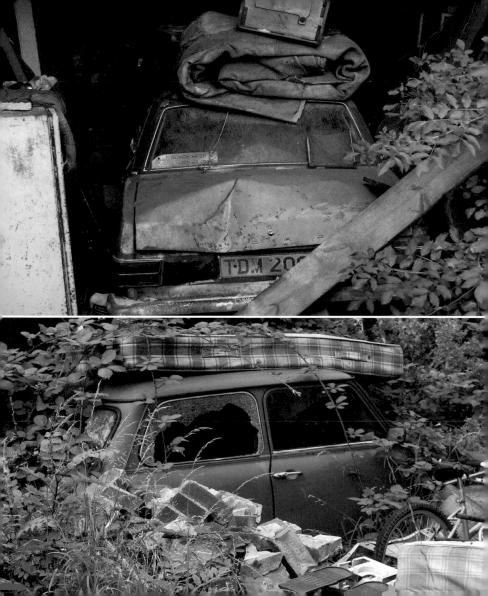

CLAPHAM ROAD SW9

CLAPHAM PARK ROAD SW4

FEEL THE POWER
BEST SHAVE

RANELAGH GARDENS SW6

WEAK
FIELD
FLAG
UP

Fighting

Pill Boxes and Shelters

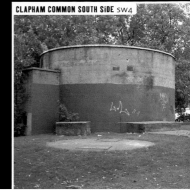

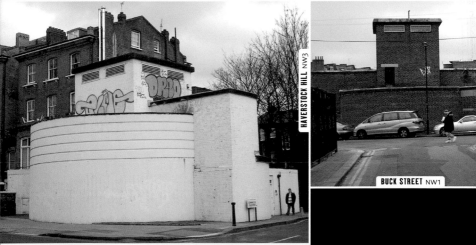

HAVERSTOCK HILL NW3

BUCK STREET NW1

Pillboxes

Putney sw15 and Bow e3

Pillboxes are among the most easily recognisable
survivors of the 1940 defences hastily built all
over the British Isles to deal with an anticipated
German invasion. They were designed to serve as
local strongpoints, manned by a garrison of one
to ten men armed with rifles and light or heavy
machine guns, which were fired through narrow
slits in the wall. Some pillboxes were equipped with
a mounting to support one or more machine guns
in an anti-aircraft role.

Over 18,000 concrete pillboxes were
constructed, and quite a large number still survive.
Their walls are usually so thick that demolition
is deemed to be more trouble than it is worth.

The top
photograph shows an unusually located pillbox
that sits awkwardly on top of a bridge beside Putney
Bridge railway station. The bottom pillbox is located
in Bow beside the River Lea.

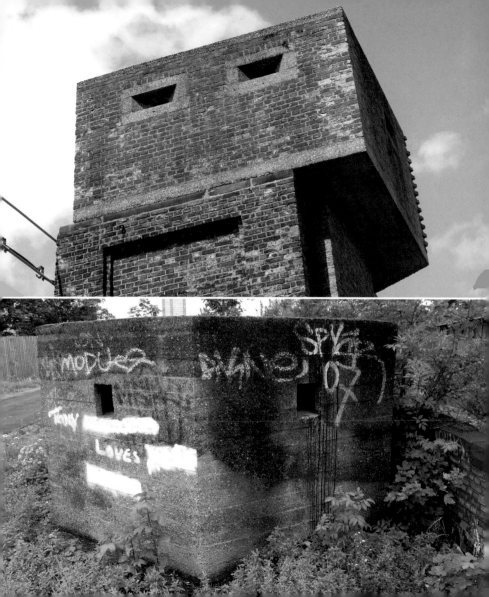

The Citadel

The Citadel was built in 1940 as an operations centre for the Navy and was linked to government buildings in Whitehall and beyond by a deep-level tunnel. The concrete roof and walls are 12 feet thick and designed to withstand the impact of a 500lb bomb. In the event of a German invasion, it was intended that the building would become a fortress, with firing positions provided to fend off attackers. Several thousand government officials could be accommodated for up to three months at a time.

Sir Winston Churchill described the Citadel in his memoirs as a 'vast monstrosity which weighs upon the Horse Guards Parade'.

In an attempt to disguise the original function of the building, it is now covered with Russian vine.

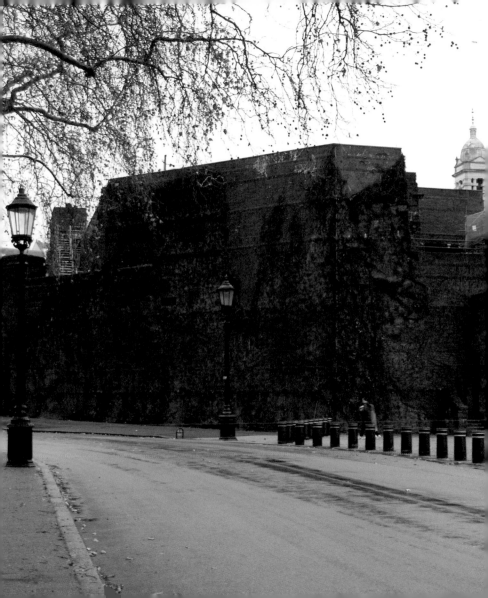

Second World War Shelter Signs

In 1935 British prime minister Stanley Baldwin published a circular entitled *Air Raid Precautions*, inviting local authorities to make plans to provide air raid protection in the event of war. The result was the building of a number of public air raid shelters, but because they were often cold, damp and dark, they proved unpopular, and householders were soon being encouraged to make their own arrangements and to build private shelters on their properties (for instance, Anderson shelters), or within their houses (Morrison shelters), with materials supplied by the government.

The top picture signposts the bomb shelter in Ladywell Fields; the bottom sign is to be found in Westminster.

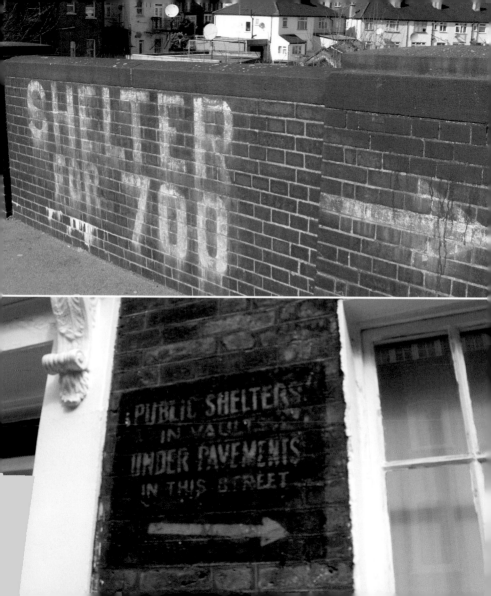

Second World War Deep-Level Shelters

Goodge Street (top picture) and Stockwell (below) were two London Underground stations that had deep-level air raid shelters constructed underneath them during the Second World War, each designed to hold up to 8,000 people.

The Stockwell shelter became a hostel for US troops; the Goodge Street shelter was employed by General Eisenhower to broadcast the announcement of the invasion of France in 1944 and then continued in use as an army transit centre. A fire at Goodge Street in 1956, however, caused such alarm and proved so difficult to put out that the Minister of Works had to assure the Commons that the shelters would never again be used for human occupation in peacetime.

HIGH STREET N16

ROMFORD ROAD E8

Resting

ROSSLYN HILL NW3

LINDEN GROVE SE15

ROMFORD ROAD E7

HACKNEY ROAD E2

LANE SW13

St Dunstan in the East

This Anglican church situated near the Tower of London dates back to 1382 and was partially destroyed by the Great Fire of London in 1666. It was then rebuilt by Christopher Wren in 1668, but reduced to a shell by German bombs during the Blitz in 1941. Wren's tower and steeple survived, however, and now house the offices of a small health clinic.

There is now a beautiful walled garden within the ruins of the old church, providing a haven of tranquillity in the heart of the City of London.

Crossbones Burial Ground

In medieval times this was an unconsecrated graveyard for prostitutes or 'Winchester Geese' (so-called because the Bishop of Winchester, a city famous for its geese, owned land in the red-light district of Southwark). By the eighteenth century it had become a paupers' burial ground. This finally closed in 1853, by which time some 15,000 people are thought to have been buried here, including (possibly) many plague victims.

The graveyard was rediscovered when bodies were unearthed during the building of the Jubilee Line in the 1990s. Roman remains and artefacts were also found here.

The site is currently in use as a builders' yard. London Transport, who own the site, want to build offices here, but Southwark Council have refused planning permission. Local people have erected a memorial shrine to the outcast dead on the gates.

Nunhead Cemetery

This, the 'Cemetery of All Saints', was the second (after Highgate) to be planned by the London Cemetery Company.

The 52-acre site was opened for burials in 1840 and was much used by the upper classes of South London. Buried at Nunhead are heroes who fought at the battles of Trafalgar and Waterloo, as well as a gallant airman who lost his life chasing an enemy Zeppelin across London's skies.

In the late 1970s the Anglican chapel, which dates from 1844, fell victim to an arson attack, and the interior and roof were completely destroyed. In the last decade or so, the cemetery has become so overgrown and neglected it resembles a jungle. An organisation called the Friends of Nunhead Cemetery has been cleaning it up and trying to transcribe as many of the memorials as possible.

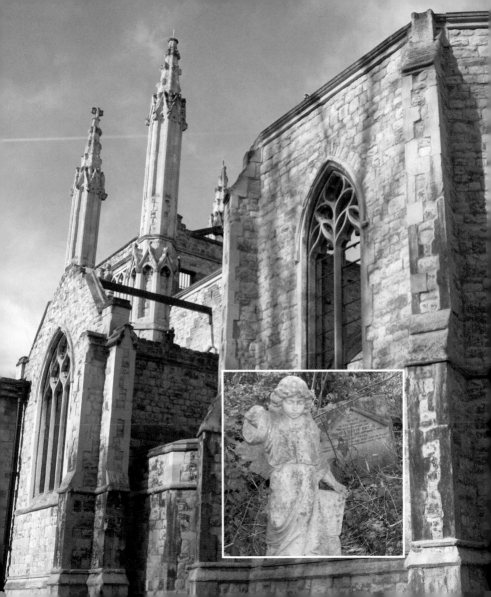

Abney Park

Built in 1840 on the site of a Quaker girls' school, Abney
Park was the first wholly non-denominational cemetery
in Europe, conceived as a 'rural cemetery' modelled on
Mount Auburn in the United States.

In the heart of the park
lies the derelict 150-year old Abney Park Chapel,
which blends Gothic and Romanesque features as
though to emphasise its non-denominational nature.
It also boasts rare ten-part rose windows.

By 1980 the park
had been passed to the local council as a disused
burial ground and open space. Since then, nature has
been allowed to take its course, burials taking place
only very occasionally in those cases where families
previously held plots from the cemetery company.
Today Abney Park is a local nature reserve and a
centre for the arts and for stone masonry training.

Royal Garrison Church of St George

Woolwich SE18

Lord Herbert, secretary of state for war, authorised
the building of St George's Church, situated next to the
Royal Artillery Barracks, using designs produced by the
Earl of Pembroke based on Wilton parish church near
Salisbury. The church was consecrated in 1863.

The walls were
encased in marble and over the following decades 300
memorials, banners, marble prayer desks, altar rails and
an elaborate lectern were installed. The Royal Artillery
Victoria Cross Memorial was placed in the apse after
the First World War. The memorial (an Italian-style
mosaic) shows St George flanked by marble tablets
inscribed with the names of those members of the
regiment who were awarded the Victoria Cross.

The church
was named the Royal Garrison Church after a visit by
King George V in 1928, but it was virtually destroyed
in 1944 by a German V1 flying bomb. The ruins today
remain consecrated as a memorial church, and the
Victoria Cross Memorial remains in good condition.

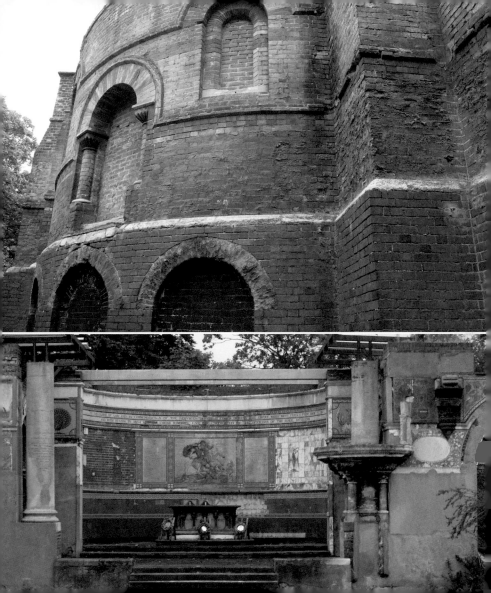

FIELDGATE STREET E1

ISLE OF DOGS E14

BARKING ROAD E16

PALMERS GREEN N13

Tachbrook Triangle

Pimlico SW1

2005 and 2007

Owing to wartime bombing only eleven properties
remain of the Georgian Vauxhall Bridge Road.
Along with the Triangle's parade of shops, they were
compulsorily purchased by the council and twice
scheduled for demolition; first for a 1980s road
scheme, then to allow for a commercial development.
But while the shops were demolished in 2001, the
Georgian Society and Save Britain's Heritage managed
to get this 1820s terrace grade II-listed before the
bulldozers could go in.

The houses remained boarded up
and home to a few squatters until being carefully
renovated under the watchful eye of English Heritage.
They are now worth almost £1 million each.

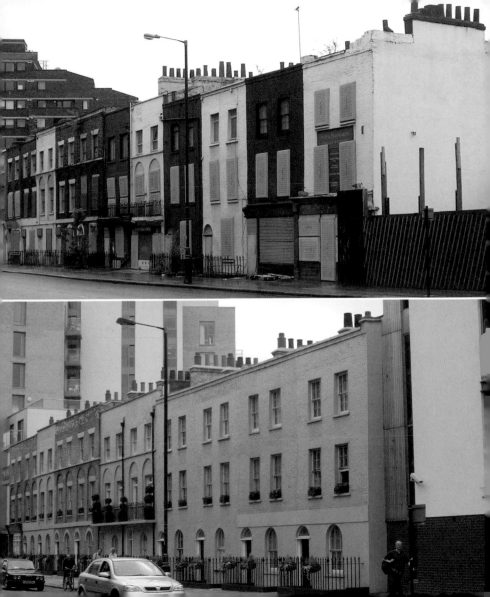

German Gymnasium

German immigrants formed the first gym club in
Britain and opened their German Gymnasium in 1864,
possibly the first purpose-built gymnasium in Britain.
Ironically, this centre was bombed by the Germans
during the First World War in 1917.

The National Olympian
Association held its first ever Games here in 1866.
These continued annually until the modern Olympic
Games were held at White City in 1908. The building
was then bought by the Great Northern Railway to
provide accommodation for its operations centre.

After a
period of neglect, the building, which is sandwiched
between the redevelopment sites of King's Cross
and St Pancras stations, is now used as an exhibition
centre.

Providence Row
Refuge and Convent

Spitalfields E1
2003 and 2007

The Catholic Sisters of Mercy set up a charity and
established a night shelter here in 1868, taking in over
250 people. The refuge also served as a training home
for servants. The accommodation was described as
being of the simplest, not to say primitive, kind.

Jack the Ripper
victim Mary Kelly is alleged to have stayed here. She
met her gruesome end in Miller's Court opposite (now
the City of London Corporation Offices).

Only the facade
of the original building remains, new offices having
been built immediately behind this shell. A housing
association set up by the original Providence Row
charity in 1970 still exists today, based in nearby
Bethnal Green.

The Elephant and Castle

Vauxhall SE11

2004 and 2007

I remember seeing this pub from the train every time
I travelled to Waterloo as a youngster. At the time I
misguidedly thought that this was in fact the area
called the Elephant and Castle.

A visitor to the pub in the 1970s
described it as follows: 'It was like an episode of some
historic British programme except it was real. Heavily
pungent with workers' underarm smell, and misty with
cigarette smoke, lighting which seemed to come from
only a handful of low wattage light bulbs in various
elderly forms of light fittings and a lady who you could
charitably say had seen better times and who was on
perhaps too many port and lemons, warbling away to
an out-of-tune piano. Her hair had been dyed a sort of
straw yellow but an inch either side of her parting had
reverted to iron grey and white.'

After becoming derelict for a
short while, the pub is now a Starbucks Coffee shop.
A sign of the times.

Tower House

Tower House began life as a Rowton House, one of a chain of hostels built to provide decent accommodation for working men in place of the squalid lodging-houses of the time.

Writer Jack London called Tower House the 'Monster Doss House' in *People of the Abyss*, his 1902 journey through the poverty of London. He said it was packed with 'life that is degrading and unwholesome'. Joseph Stalin spent a fortnight in a sixpence-a-night cubicle here in 1907, when he attended the Fifth Congress of the Russian Social Democratic Labour Party across the road. It was at this congress that the Bolsheviks consolidated their power.

After two decades of decay, the building has now been converted into luxury flats for rental at over £300 per week for a one-bedroom apartment.

South London Hospital for Women

This hospital, designed for women patients and staffed entirely by female medics, was opened by Queen Mary in 1916. It offered first-class medical care and also good career prospects for its medical practitioners at a time when many hospitals refused to employ women. It was enlarged in the 1930s and finally closed down in 1984. A petition protesting against closure was signed by 60,000 people, and the hospital building was occupied for nine months by protesters.

After bitter legal wrangling and two judicial reviews against planning decisions, the building was redeveloped. At first glance little appears to have changed, but in fact only the original facade of the original building now remains. The rebuilt structure hosts over a hundred flats and a Tesco supermarket.

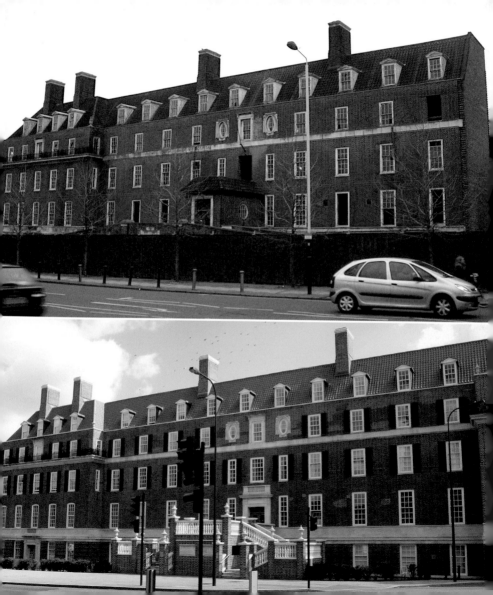

Island Block

In a Channel 4 poll of 10,000 viewers to find the ugliest buildings that people would most like to see demolished, this came in at number 11. A six-storey concrete building, it was constructed in the early 1970s as an extension to the old Greater London Council's County Hall complex and its prominent location made it perhaps the most noticeable of all London's derelict buildings.

It has recently been demolished and permission to construct a 13-storey 743-bed hotel has been granted.

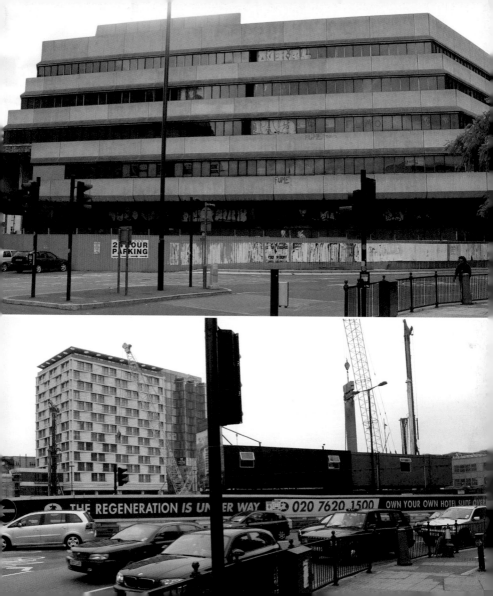